IMAGES
of America

W. R. CASE & SONS
CUTLERY COMPANY

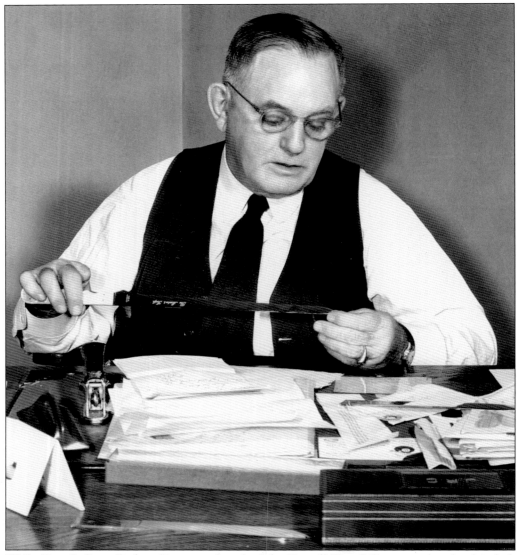

W. R. Case & Sons Cutlery Company founder John Russell "Russ" Case is pictured at his desk with the Masters' Tool, a genuine mother-of-pearl carving knife from the 1940s.

On the cover: In the early years at Case, knife blades were ground by hand on large floor grinding wheels. This was difficult work, to put it mildly, with the operator sitting in a saddle over the wheel. The hard stone grinding wheels were 3 inches wide and 48 inches in diameter, weighing between 500 and 600 pounds each. A special hoist was needed to put a new wheel into place. The manufacturer recommended a ring test be done before starting, to check for cracked wheels. This involved tapping the wheel with a wooden object, such as a hammer handle. If the wheel made a high-pitched ring, it was okay to use. If there was not a high-pitched ring, there was probably a crack, which could cause the wheel to break when in use.

IMAGES of America
W. R. CASE & SONS CUTLERY COMPANY

Shirley Boser and John Sullivan
Foreword by John R. Osborne Jr.

ARCADIA

Copyright © 2006 Shirley Boser and John Sullivan
ISBN 978-0-7385-3937-9

Published by Arcadia Publishing
Charleston SC, Chicago IL, Portsmouth NH, San Francisco CA

Printed in the United States of America

Library of Congress Catalog Card Number: 2005933196

For all general information contact Arcadia Publishing at:
Telephone 843-853-2070
Fax 843-853-0044
E-mail sales@arcadiapublishing.com
For customer service and orders:
Toll-Free 1-888-313-2665

Visit us on the Internet at www.arcadiapublishing.com

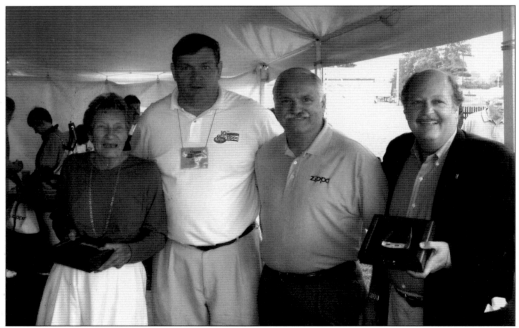

Company owners Sarah Dorn (left) and her son George Duke (right) are pictured during National Zippo Day in July 2003 with Case president Tom Arrowsmith (second from left) and Case chairman and Zippo president Greg Booth. The mother-of-pearl presentation knives celebrated the 10th anniversary of Zippo Manufacturing Company's acquisition of W. R. Case & Sons.

Contents

Acknowledgments — 6

Foreword — 7

1. The Early Years — 9

2. W. R. Case & Son Cutlery Company, Little Valley, New York — 17

3. Bank Street Factory, Bradford, Pennsylvania — 21

4. Russell Boulevard Factory — 35

5. South Bradford Factory — 87

6. The Case Collectors — 109

Acknowledgments

This book would not have been possible without the help and support of so many. Listing names is always dangerous, so please accept our apologies in advance for any we miss. Our thanks start with the members of the Case family, who have so kindly shared their photographs and stories not only for this book, but to help rebuild the Case company archives. They include Brad Lockwood, Donna Case, Elliott Case, John Burrell, Mary Joan Muth, Michael Kerns, Minnie Case, and of course, Case legend John R. Osborne Jr. Also, we would like to extend a special thanks to the Jack Ellis family for Jack's help with photographs from Little Valley, New York.

Current and retired Case associates went out of their way to provide pictures and help us place a name or a date. We want to particularly thank Case Wall of Fame members Bob Farquharson, and E. L. "Shine" Jessup, along with longtime Case salesman Louis Graves for their many contributions. Thanks also to Andy Norcross, Bertha Peterson, Carla Hervatin, Cheryl Lapallo, Dale Clark, Dave Jack, Dick Skillman, Eddie Jessup, Erica Runyan, George Abrams, George Deming, George Slotta, Harry Solarek, John Lombardi, Kathy Miller, Lisa Boser, Pat Pessia, Ralph Banks, Rose Hvizdzak, Shelley Swanson, Shirley Barrett, Skip Lawrie, Tim Geiger, Toni Frontino, Whitey Peterson, and Zana Verolini. Linda Meabon and Steve Mahon from Zippo were also very helpful on this project.

Case customers, collectors, and friends also made this book possible. Our thanks go to Kevin Pipes of Smoky Mountain Knife Works, the Reid family from Shepherd Hills Cutlery, Bob Wurzelbacher, Brad Wood, Mrs. Dewey Ferguson, Mary Rose Cuiffini, Jim Sargent, and the Tom Hart family. Finally, we'd like to thank Case president Tom Arrowsmith for his tremendous support on this project. He really helped us pull the story of this great company together.

The images in this book are generally in chronological order. However, some photographs were used out of sequence to better tell the story.

W. R. Case & Sons Cutlery Company registered trademarks:
CopperLock®
Hammerhead®
Kodiak®
Mini-CopperLock®
RussLock®
Tested XX®

Foreword

Today is a snowy November day, and it strikes me that it was probably a day just like this, 100 years ago, that the first knives were rolling off the line at W. R. Case & Sons new factory in Bradford, Pennsylvania. For more than a century, the Case name has been synonymous with high-quality cutlery and pocketknives that are hand crafted, with bone, stag, or pearl handles and are cherished for generations. That sort of longevity is certainly unusual, especially in today's business environment, but when I think about the famous Tested XX knives and the people involved it is really not so surprising.

My great-uncle Russ Case started the company, naming it after his father, W. R. Case. Uncle Russ was quite a character, incredibly competitive and a true entrepreneur. How competitive? On fishing trips to Canada, he would challenge the guide to a wrestling match. He once ran through a barbed wire fence in order to win a footrace. Horse races, cards, Russ was up for just about any game. He also liked to play the occasional practical joke. I have a tendency to swear more than I should, and I am sure it all came from Russ Case. When I was learning to talk, he would jokingly tell me to "go tell your grandmother she's a real s. o. b." or some comment like that. My grandmother was Rhea O'Kain. She was Russ's niece, and the apple of his eye. So of course I told her, and he thought it was really hilarious.

When it came to knives, Russ was equally competitive. Simply put, a knife that would bear the Case name had to be the best. He was an innovator, creating new knife designs like the famous Case Folding Hunter, and a pioneer in the use of stainless steel for both pocketknives and household cutlery. Under that competitive and somewhat gruff exterior, Uncle Russ really had a heart of gold. For example, even as business was slow during the Great Depression, Russ would not lay anybody off. He kept people working, even if that meant digging fence posts on his farm or scraping ice in the parking lot. He sometimes did things that weren't necessarily good for the business, but they were good for his people.

Uncle Russ was a great salesman and kept the company going as much through his incredible tenacity as anything else. A wheeler-dealer, he didn't necessarily possess the best management skills. John O'Kain (married to my grandmother Rhea Crandall Osborne O'Kain) brought a strong business sense to Case and more than made up the difference. He recognized that Case had to streamline operations in order to remain competitive. The company offered hundreds and hundreds of different knives in its line. Some of these were so specialized that only a few dozen were sold each year. How good a manager was John O'Kain? Well, he would run the Case factory in the morning, have lunch at the Model T Inn, and then run the Alcas factory in the afternoon.

My own career at Case started when I was in high school, counting inventory over Christmas break. One summer, I worked with Joe Petro (pictured on page 41) learning how to wire knives on display boards. Later, working in operations, I reported to John O'Kain, making recommendations on which knives should stay in the line. He was always trying to streamline the business. In the 1970s, as vice president of manufacturing, I oversaw the building of the Owens Way factory and also focused on new product development. This was the same time

period when the interest in collecting Case knives was starting to blossom. No doubt, Case collectors were looking for those knives John O'Kain and I decided to discontinue from the line!

The company has certainly been through some incredible changes in the last 20 years. There were some rough times, with changes in ownership. For a while, I frankly wasn't sure the company was going to make it. It has been great to see the rebirth of Case over the last decade, with the committed owners at Zippo Manufacturing Company, the management team headed up by Tom Arrowsmith, and of course the great knife makers in the factory; the company is again on solid ground.

Since leaving the company more than 20 years ago, I have been involved in different business ventures and had forgotten how much fun the Case knife business can be. There is just something special about a Case pocketknife. Participating in Case Legends tour stops over the last few years has given me the chance to reconnect with Case collectors and share in their enthusiasm for this company started by my great-uncle more than a century ago.

The story of W. R. Case & Sons Cutlery Company, and the people involved, is truly an incredible one. I hope you enjoy this book.

—John R. Osborne Jr.

John R. Osborne Jr. is a Case Legend and the last Case family member involved in the management of the company.

One

THE EARLY YEARS

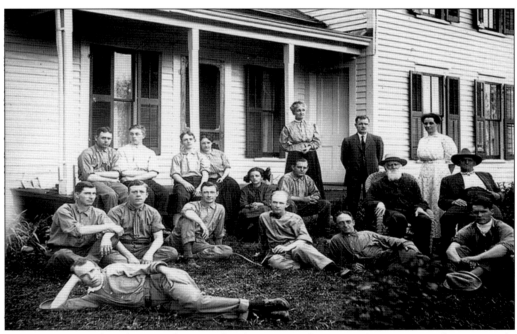

An American cutlery dynasty, the Case family is pictured at W. R. Case's country home outside Little Valley, New York. W. R. is seated in the chair on the far right next to his father, Job Russell Case. Standing behind them are Harvey Platts and his wife, Debbie Case Platts. John Russell "Russ" Case and his niece Rhea Crandall are seated on the porch steps.

William Russell "W. R." Case, the company namesake and the first son of Job Russell Case, was born in 1847 in Napoli, New York. In the early 1870s, W. R. headed West on the wagon trails with his brother Jean Case, settling in Spring Green, Nebraska. After establishing a homestead, he was joined there by his wife Mary Fox Case (below) and their daughter Debbie. W. R. and Mary had three more children in Nebraska: Maude, who died as a baby, followed by Theresa, and then Russ. Mary died shortly after Russ was born, so W. R. returned to Little Valley, New York, with his three children. In Little Valley, W. R. was involved in several cutlery operations, but his calling was always farming. Some years later, W. R. helped Russ start a new company, W. R. Case & Sons, even taking on the role of president.

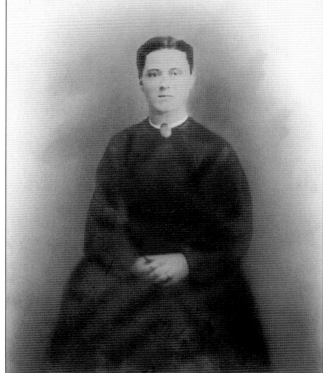

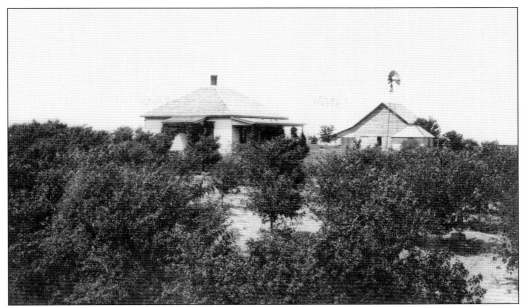

The Case family heeded the call to "go west." Their pioneering spirit took them to Spring Green, Nebraska, where they worked in lumber, farming, shipping, cattle, and horses. This is W. R. Case's second home in Spring Green (the first was a sod house) and the birthplace of his son, Russ.

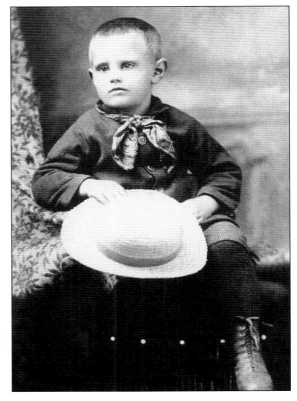

Life on the Nebraska plain was exciting for young Russ Case. He enjoyed watching the prairie dogs at play or getting into some mischief with his cousins Elliot and Dean Case. One Halloween prank on their teacher got out of hand when they caught their schoolhouse on fire. Russ, the star of this story, would later start W. R. Case & Sons Cutlery Company.

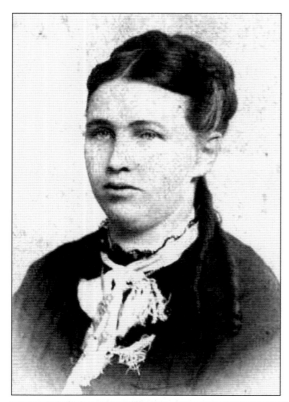

The women of the Case family played a major role in the cutlery business, but it was W. R. Case's sister Theresa Case Champlin (above) that got them their start. Her husband, John Brown Francis "J. B. F." Champlin, was a knife salesman and owner of J. B. F. Champlin & Son Cutlery Company. When W. R.'s wife Mary died in Nebraska, Theresa convinced her brothers Andrew, John, Jean, and W. R. (pictured below, from left to right, with their father, Job Case) to return to Little Valley and work with her husband. The Case brothers did just that, joining Champlin to form Cattaraugus Cutlery Company.

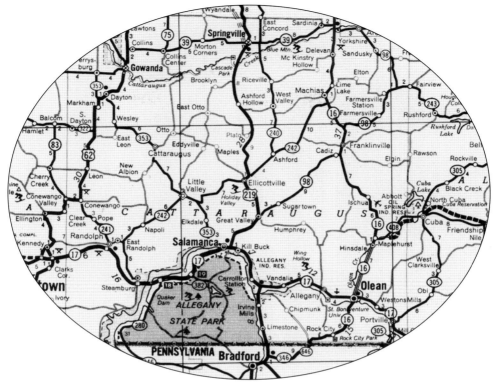

This map shows Little Valley, New York, and Bradford, Pennsylvania. Like Sheffield, England, or Solingen, Germany, this circle represents the heart of the cutlery industry in the United States. An area rich in resources, including lumber, oil (the first well was drilled in Titusville, Pennsylvania, in 1879), and capital, some 70 different cutlery companies eventually operated within 100 miles of this circle.

J. B. F. Champlin started the Cattaraugus Cutlery Company in 1886, with help from his son Tint and the Case brothers: W. R., Andrew, Jean, and John. While the Case brothers only stayed with Cattaraugus for a year or so, another important connection took place there. W. R.'s daughter Debbie Case met and married Harvey Platts while both were working there. Cattaraugus Cutlery, the first cutlery company that involved the Case family, remained in business in Little Valley until 1963.

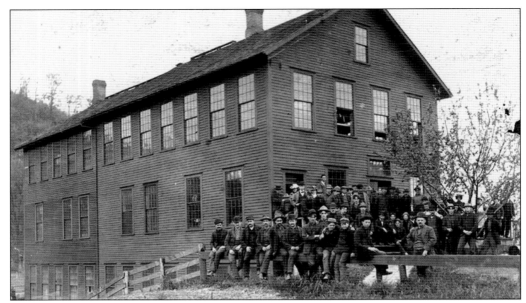

Although they only spent a short time at Cattaraugus, Jean, John, and Andrew Case were all drawn back to the cutlery business. They started Case Brothers Cutlery as a jobber (distributor), operating out of Job Case's garage in Little Valley. In 1900, they incorporated and built a new factory (above) to manufacture their knives. W. R. Case became involved with the corporation as a stockholder and served on the board of directors but was not involved in the daily business affairs. This factory remained in operation until it burned to the ground in 1912.

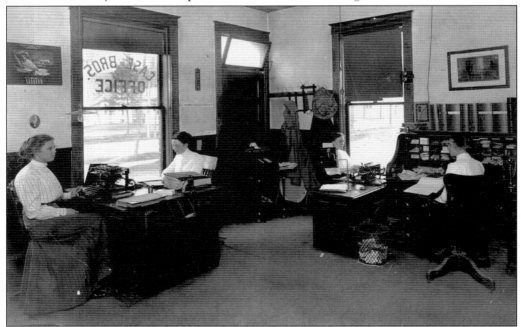

Working in the Case Brothers office, from left to right, are Lina Champlin, Agnes Kelley, Zelo Chesbro, and Addie Case (daughter of Jean Case). Of the Case brothers, Jean was the most involved in the daily operations of the company.

One of Case Brothers' most successful salesmen was W. R.'s son, Russ Case. This invoice dated July 1, 1899, is made out to Russ Case, who was working in Spring Green, Nebraska, at the time.

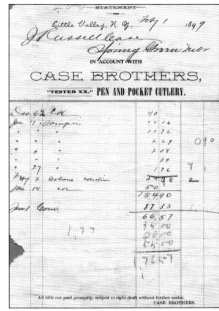

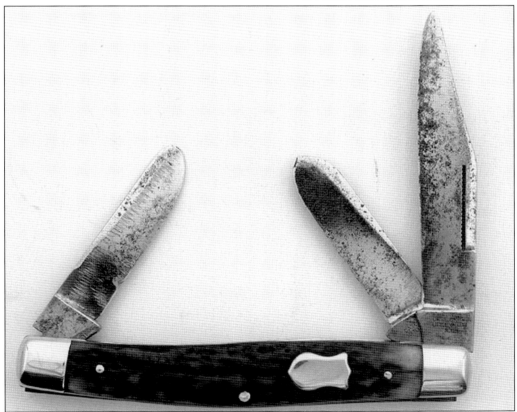

Pictured is an example of an early Case Brothers Little Valley, New York, knife. This 5375 stockman knife does not feature the XX blade stamping often found in later Case Brothers knives.

Russ Case was an outstanding salesman for his uncles at Case Brothers. Pictured here are one of his commission reports (above) and his business card (below). These commission amounts were staggering to Case Brothers. The story is told that Russ was earning more money in commissions than they were for operating the factory. Their proposed solution to this problem was changing his compensation to a flat salary. This idea did not sit too well with Russ. He could see the writing on the wall. The best chance he had to really be successful was to branch off and start his own company. With the help of his father, W. R., Russ did just that.

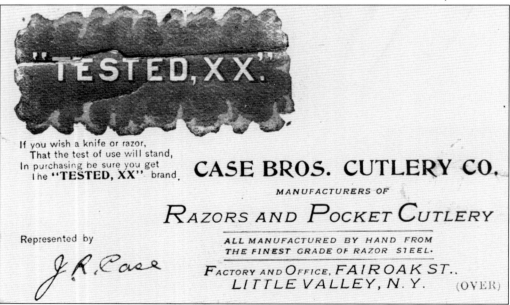

Two
W. R. Case & Son Cutlery Company, Little Valley, New York

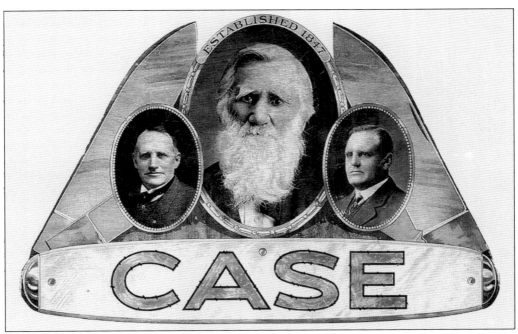

This early logo design for the new W. R. Case & Son Cutlery Company has been described as the "Father, Son and Holy Job." Three Case generations are pictured: W. R. on the left, Russ on the right, and Job Case in the center. "Established 1847" reflects the birth date of W. R. Case. Russ was a shrewd marketer and used this logo to give his new company an older, more established look.

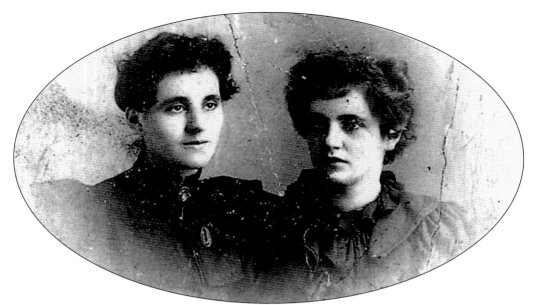

Sisters Debbie and Theresa were strong influences in Russ's young life, due in part to the bonds that grew between them following the death of their mother. Through marriage, they created bonds between the Case family and other cutlery families. Debbie married Harvey Platts of C. Platts & Sons Cutlery Company of Eldred. Theresa married Herbert Crandall of Crandall Cutlery. Both Platts and Crandall would play integral roles in the development of W. R. Case & Sons.

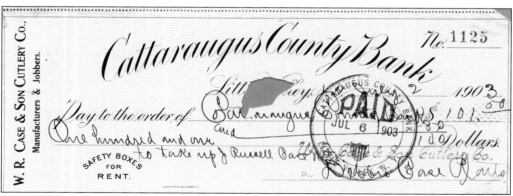

Debbie Case Platts was a big help to her brother, taking care of the book work at the office and overseeing things while he was on the road selling his wares. This was a W. R. Case & Son Cutlery Company check written by Debbie for payment of a loan at the Cattaraugus County Bank in Cattaraugus, New York.

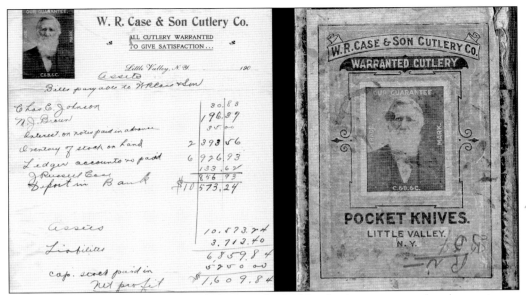

From the income statement printed above, it looks like the business was already starting to earn Russ a little profit. On the right is an image of a knife box from W. R. Case & Son Cutlery Company in Little Valley. Note the continued use of Job Case's image on both pieces. This was a point of contention between Russ and his uncles at Case Brothers.

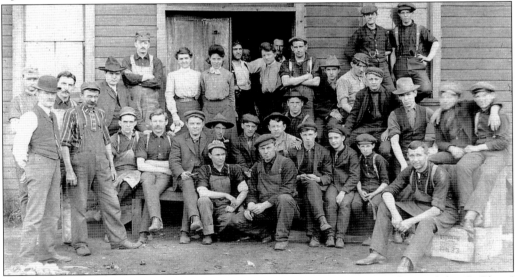

Harvey Platts (left in derby and vest) is pictured with his workforce in front of the C. Platts' Sons factory in Eldred, Pennsylvania. Harvey's father, Charles W. Platts, emigrated from Sheffield, England, in 1864, bringing with him the knife-making skills that helped build the cutlery industry in America. After working as superintendent of Northfield Knife Company in Connecticut, Platts managed production for Cattaraugus Cutlery Company. He then started his factory, C. Platts & Sons. The Platts factory built many of the knives sold by Case Brothers and W. R. Case & Son. When Charles Platts died, the company was renamed C. Platts' Sons. Harvey ran the company, eventually buying out his brothers' shares. They would move on to start Platt Brothers in Andover, New York.

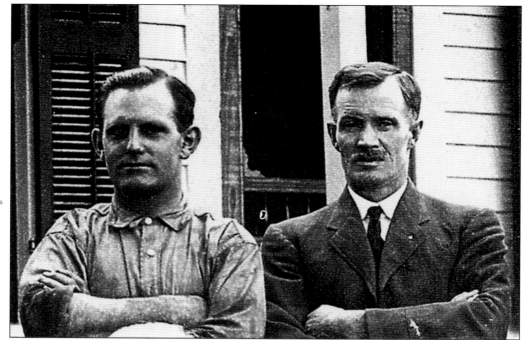

Brothers-in-law Russ Case and Harvey Platts (above, right) joined forces at the end of 1903 to form a new company named W. R. Case & Sons Cutlery Company, based in Little Valley. The name change from "Son" to "Sons" was subtle but worked since Harvey was W. R. Case's son-in-law. With the combined strengths of Russ's sales and marketing savvy and Harvey's knife-making expertise, they started to look for a place to build a new factory. Their search led them to Bradford, Pennsylvania (below), a small town some 30 miles from Little Valley, bustling from the oil boom of the late 19th and early 20th centuries.

Main Street, Bradford, Pa.

Three

BANK STREET FACTORY, BRADFORD, PENNSYLVANIA

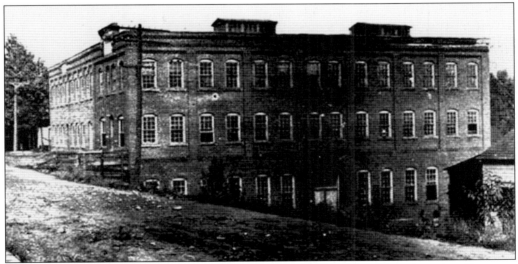

W. R. Case & Sons's Bank Street factory was built in 1905 by Tuna Manufacturing Company of Bradford, Pennsylvania, for a total cost of $6,500. W. R. Case was the president. Russ Case was vice president and sales manager. Harvey Platts was secretary and superintendent of the factory. George H. Potter was treasurer. The largest stockholder was Theresa Case's husband, Herbert Crandall. Much of the knife-making equipment would come from the Platts factory in Eldred, Pennsylvania.

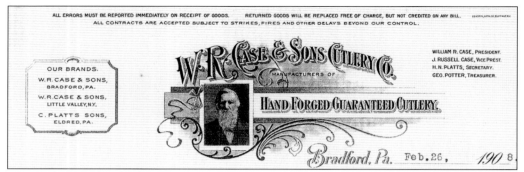

This early letterhead tells the story. The "Our Brands" box on the left side highlights three companies joined to form one: W. R. Case & Sons—Bradford, W. R. Case & Sons—Little Valley, and C. Platts' Sons—Eldred. Corporate officers are listed on the right side, and, again, Russ uses the image of his grandfather Job Case.

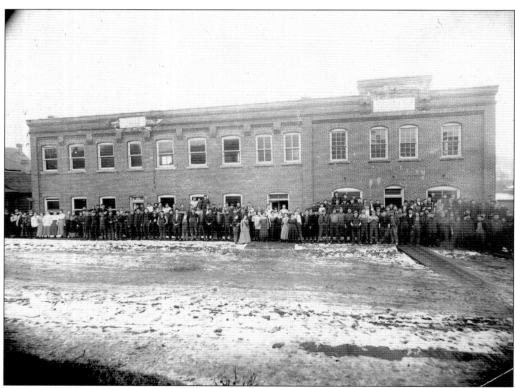

This early picture of the Bank Street workforce shows a full crew, and they would need to be careful walking on those wood planks crossing the dirt road. At this time, W. R. Case was living in a home at 90 School Street that he had purchased in April 1905. Son Russ was managing the daily operations, but W. R. was the company president.

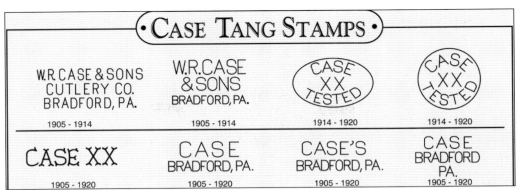

Illustrated above are examples of various tang stamp designs used by W. R. Case & Sons during its early years at Bank Street. Case collectors use these stamps to identify when a knife was produced.

Russ Case (right) is pictured here with his cousin Jean Reed on a camping trip (believed to be to Nebraska). Jean was the son of W. R. Case's sister Virginia Reed. He was a Case Brothers stockholder and served on its board of directors. Jean operated a leather company out of his home, producing sheaths and razor strops for the knife factories in the area.

Effie Case, Russ's wife, looks quite stylish in this portrait with her young niece Rhea Crandall. Russ and Effie never had any children, so Rhea was like a daughter to them. In fact, Rhea was the heir to Russ's estate and would one day own W. R. Case & Sons Cutlery Company.

Before Case salesmen would go out on the road, they would send their dealers a calling card notifying them of their planned visit. For their sales pitch, they would carry large knife rolls, spreading them out on the store counter so everyone could gather around and see the Case line.

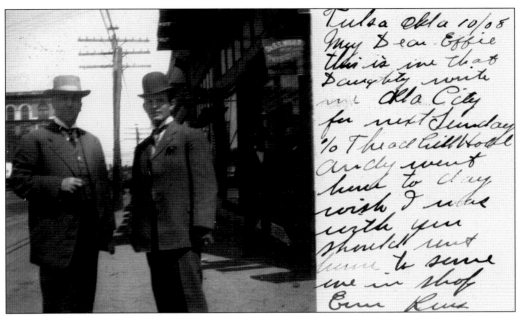

Russ Case (right) poses with one of his salesmen for the postcard above from Tulsa, Oklahoma, in 1908. Postcards were a great way for salesmen traveling on the road for months at a time to keep in touch with loved ones at home. The postcard below is most likely from the same trip. Notice the dresses the ladies are wearing.

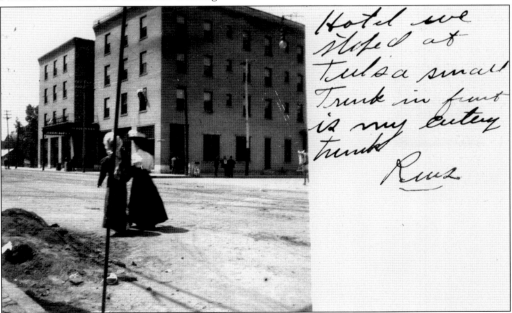

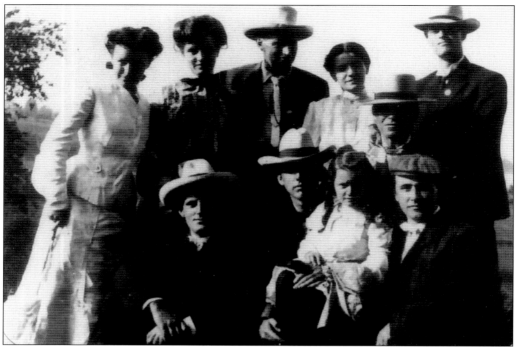

Dressed in their Sunday best, standing from left to right are Effie Case, Theresa Crandall, Jean Reed, Carrie Reed, and Harlan Barnard. Seated in front from left to right are Russ Case, Herbert Crandall with Rhea Crandall, and Dean Case. The gentleman on the right behind Rhea and Dean is unidentified.

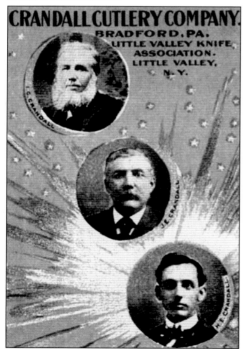

Russ Case had another brother-in-law in the cutlery business. Herbert Crandall's first cutlery company was a jobbing firm named Little Valley Knife Association, based at his home in Little Valley, New York. In 1903, he founded Crandall Cutlery Company in Bradford, Pennsylvania, building a new factory that would go into operation in 1905. This Barbour Street factory was just a couple of blocks away from the new W. R. Case & Sons factory on Bank Street. Another similarity between the companies can be seen in this advertising piece, with Herbert using pictures of older members of the Crandall family in the logo.

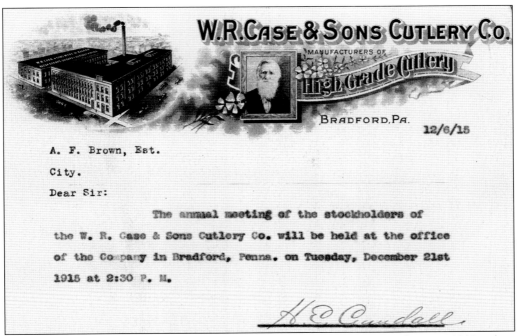

Herbert Crandall took on a far more important role at W. R. Case & Sons in 1911, when Harvey Platts, diagnosed with grinders' consumption, left Bradford for the fresh air of Colorado. Crandall (W. R.'s other son-in-law) merged his business with Russ Case and helped save the company. This is a stockholders meeting notice signed by Crandall in 1915 when he was secretary of the board.

This 1915 birthday card from Theresa Crandall to her brother Russ Case attests to the strong bond they had. It was found in a box of papers by her great-grandson John Russell Osborne Jr.

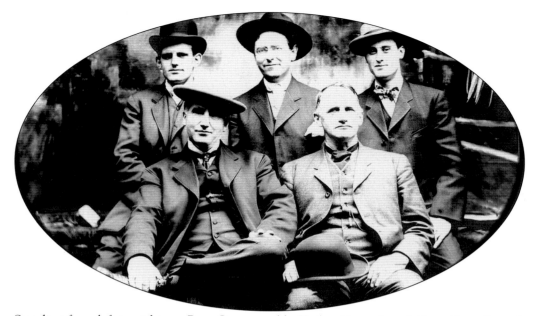

Standing from left to right are Russ Case, possibly Harlan Barnard, and Dean Case. Seated, from left to right, are Andrew Case and W. R. Case. Andrew Case had been operating Case Manufacturing Company, which was purchased by W. R. Case & Sons in 1911. After the business sold, Andrew would work as a salesman for Russ Case.

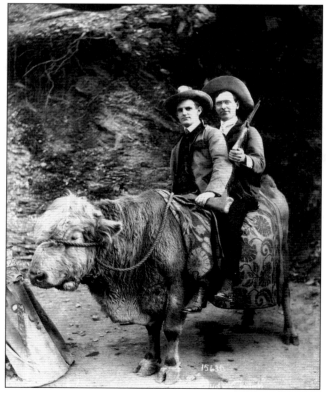

The ever-adventurous Russ Case appears on a bull at Bloody Gulch with who is believed to be Harlan Barnard around 1915. Barnard was with W. R. Case from the beginning, as a major stockholder, and served as company vice president for many years.

After fire destroyed Case Brothers' Little Valley factory in 1912, the company relocated operations to Springville, New York (above). Case Brothers was never able to recover from this devastating loss. Poor sales, financial problems, and corresponding family disputes forced it out of business. The company filed for bankruptcy in May 1915.

W. R. Case & Sons purchased assets and equipment from Case Brothers when it was going out of business. The most important acquisition was the famous Case Brothers Tested XX trademark. Each X signified the blade had been tempered and tested twice for quality. The change was incorporated into the Case logo as shown in this sign.

Case adapted its packaging to reflect the incorporation of the Tested XX trademark as shown above.

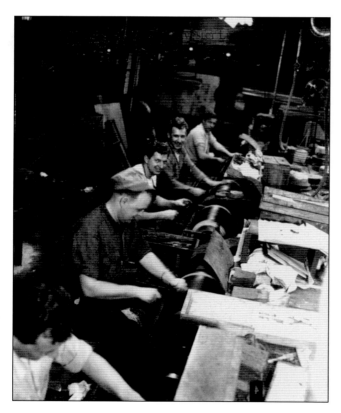

This photograph shows hafters working on the grease buff wheels at the Bank Street factory. Hafters at Case today still use the same sort of equipment to do the same operation, shaping and blending the knife by hand.

N. S. A. 514.

Contract No. 31004 Opening 12 June 1917, 191

NAVY DEPARTMENT,
BUREAU OF SUPPLIES AND ACCOUNTS.

WASHINGTON, D. C., 5 July 1917, 191

SIR:

A contract numbered as stated above and dated 9 July 1917, 191, has been entered into with W. R. Case & Son Cutlery Co. of 816 - 14th St. N.W., Washington, D.C.

for furnishing the following articles to be delivered at the place and within the time stated for each class, and at the price set opposite each item, respectively, and, unless otherwise provided, to be subject to the terms of the above contract quoted on the back hereof:

31004

Class 125.— (Req'n 364, S. and A.— New York, N. Y.— Sch. 1195.)
To be delivered at the provisions and clothing depot, navy yard, Brooklyn, N. Y., within 8 months after date of contract or bureau order.
Stock classification No. 55.

No. of item
19 81667 (about) jackknives.................each $.3949..$32250.29
 Jackknives to be in strict accordance with "Specifications 55J1," issued by the Navy Department Aug. 1, 1914, copies of which can be obtained upon application to the supply officer, navy yard, New York, N. Y., or to the Bureau of Supplies and Accounts.
 To be in strict accordance with specifications and standard sample.
Name of manufacturer: W. R. Case and Sons Cutlery Co.
Address: Bradford, Pa.
Exact location of manufactured stock: Bradford, Pa.

Liquidated damages for delayed delivery provided by Form A will not apply.
The time of delivery is an important consideration, and bidders must state clearly the shortest possible time within which they can guarantee to make delivery.
Alternate bids on any part of the total quantity required may be submitted and will be considered, and such bids are requested from bidders who may be able to make spot or prompt deliveries, and also from those whose facilities may not be adequate to permit them to submit proposals for the total quantity stated.
Bids on material not in accordance with the specification requirements will be considered... in such ...ance from the specifications must be clearly noted in red ink in the proposals; or the proposed ... each article it is proposed to furnish forwarded to the officer in charge of the provisions an... Refer... marked with the class and schedule numbers and date of opening the bids.
Samples, if submitted, must be delivered prior to the time fixed for opening the b...
will not be considered.
The right is reserved to award contracts for the quantity required among four o...
for the best interests of the Government.
Bidders must state on the blank lines provided under each class the name and address of t... material it is proposed to furnish. If the material will be supplied from stock and not specia... location where the finished material is in stock must be stated.

Respectfully,

S. McGOWAN,
Paymaster General of the Navy.

To W. R. Case & Son Cutlery Co.,
 Wash.
 D.C.

A Case 6202 EO jackknife is pictured along with the corresponding World War I order from the United States Navy Department. The order, dated July 5, 1917, was for 81,667 knives at $0.3949 each. Producing these was a huge undertaking, but it would not be the last time W. R. Case & Sons diverted production to support war efforts.

In 1925, Tint Champlin of Cattaraugus Cutlery partnered with Russ Case of W. R. Case & Sons in building a new factory in Little Valley, New York, called Kinfolks Inc. Dean Case, who was a supervisor at W. R. Case & Sons, joined his cousins, agreeing to run the operation. Three cousins were involved, hence the name Kinfolks.

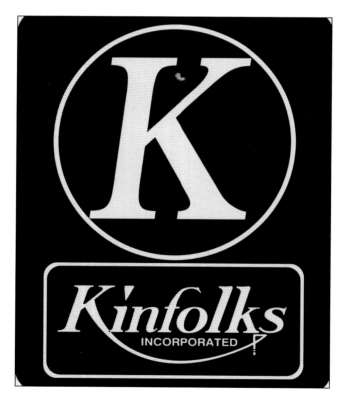

Both W. R. Case & Sons and Cattaraugus Cutlery were experiencing capacity problems. The Kinfolks factory would produce knives for both companies.

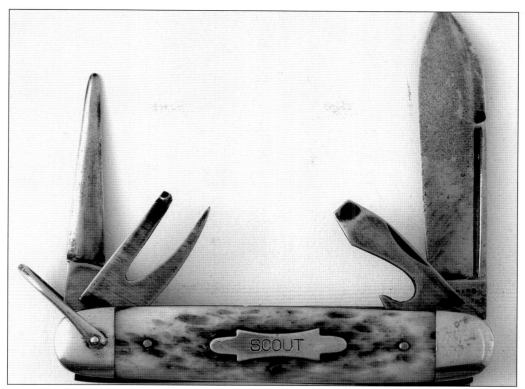

Dean Case bought his cousins' shares to become the sole owner of Kinfolks. He marketed knives under two secondary brand names: Standard Knife Company and Jean Case Cutlery Company (named for his father). This was the second time Dean used the "Standard" name, having operated a Standard Knife Company in Little Valley with his brother Elliot, who died unexpectedly in 1903. The knife pictured is a Scout pattern with Standard Knife Company stamping.

Dean Case, W. R. Case, and Harlan Barnard, seated in back, enjoy a relaxing afternoon on the porch. Russ Case is in the front on the right, and the gentleman front left is unidentified. He does appear in several family pictures, so it is thought that he is somehow related.

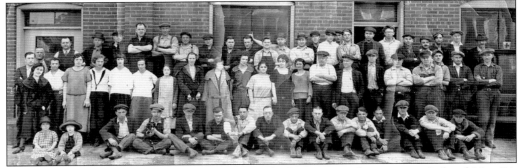

This is the last Bank Street workforce photograph the company has on record, dated May 24, 1924. The second lady from the left in the center row is Anna Petro. Fifth from the left in the same row is her daughter Mary. Note the dog being held by the man sitting in front. Perhaps there was a Case mascot?

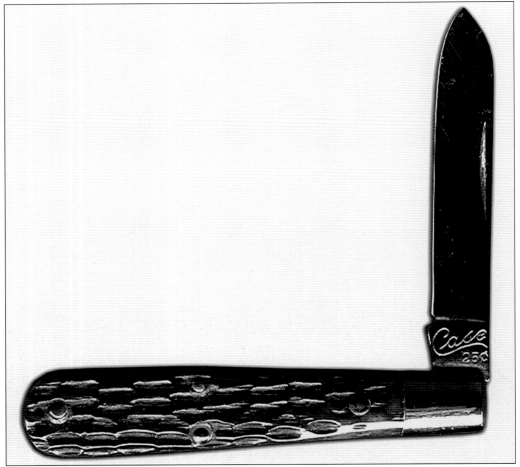

Russ Case continued to create innovative marketing ideas, like the 6106 green bone pocketknife shown here with the "25¢" tang stamping. When America was struggling through the Great Depression, Russ wanted to show the consumer that Case pocketknives were a great value. Stamping the retail price right into the blade of the knife did just that.

Four
RUSSELL BOULEVARD FACTORY

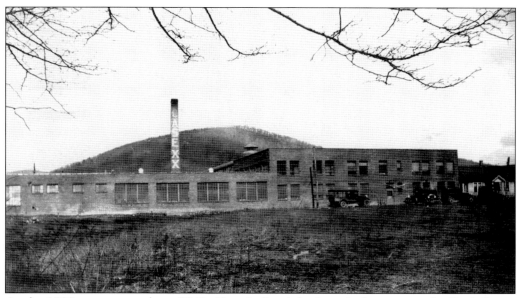

As the 1920s came to a close, W. R. Case & Sons's business had outgrown the Bank Street factory. Russ Case built a new plant near East Main Street in Bradford on Russell Boulevard. Ironically, Case moved in the weekend of the stock market crash of 1929 that signaled the start of the Great Depression.

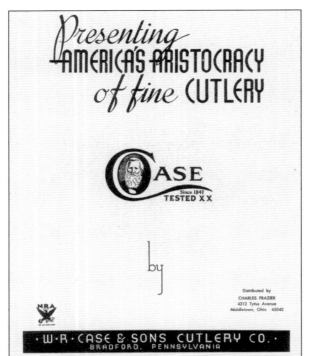

This is the cover of the oldest W. R. Case & Sons catalog the company has in its archives. Note the NRA logo for the National Recovery Administration, a Depression-era program that was part of Franklin Delano Roosevelt's New Deal. The NRA code was declared unconstitutional in 1935.

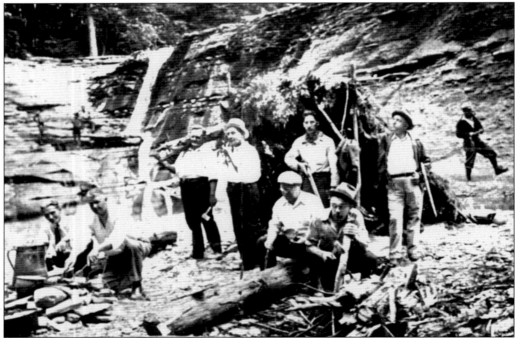

This picture from the catalog above includes Bill Finger, H. I. Prater, Russ Case, Bobby Bethea, John D. Case, Jack Nieman, Steve Simcoe, Al Krause, and Floyd Stewart. Louis Graves and Wayne Bethea are on the rock in the background. Notice the hatchet in Russ's hand. They were cutting rock slabs for the Case family monument at Lilydale, New York.

> # CASE KNIFE-AX
> ## A Perfect Combination
> ✦
> ### FOR HUNTER, CAMPER OR WOODSMAN
> ### In fact, it is just what you want for the life out of doors
> Knife and Axe blades are Chromium Plated to avoid rust or discolor
> Mfd. by W. R. Case & Sons Cutlery Co. Bradford, Pa.

This particular Knife-Ax box was used for many years in the Case Etching and Engraving Department to house etching stencils. It was rescued several years ago when Case started efforts to rebuild its historical archives.

> # CASE'S TESTED·XX·KNIFAX
>
> No. 961. KNIFAX—Combination Knife and Ax. Blade and ax interchangeable in same handle. Five inch Oriental type hunting blade. Length of ax in handle eleven and one-fourth inches. Length of ax blade four and one-fourth inches. Width of cutting edge on ax, two and one-half inches. Ax and blade Chrome finished. Total weight of ax, knife and handle in compact leather sheath, only one pound and five ounces, requiring no more space on the person than the ordinary hunting knife. It has met the universal approval of experienced hunters, campers, motorists, scouts and sportsmen. Indestructible pearl handle.
> Per Dozen $75.00
> No. 661. Same as No. 961 except with bone stag handle.
> Per Dozen $72.00
> No. 261. Same as No. 961 except with walnut handle.
> Per Dozen $66.00
>
> · W·R·CASE & SONS CUTLERY CO. ·
> BRADFORD, PENNSYLVANIA

The Knife and Ax Combination Set was a marvel in its day. The interchangeable blade and axe gave two tools in one sheath. These are treasured by Case collectors today.

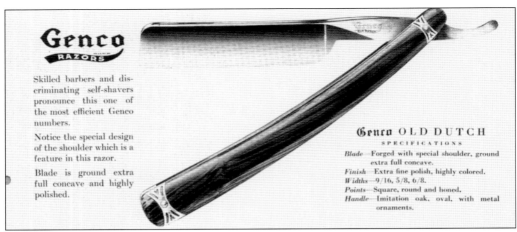

In 1935, W. R. Case & Sons purchased the razor division of Geneva Cutlery in Geneva, New York. This created a new Genco Razor Division of W. R. Case & Sons Cutlery Company. Russ Case wanted to broaden his line of straight razors. Genco razors (above) were sold alongside the W. R. Case & Sons razor models.

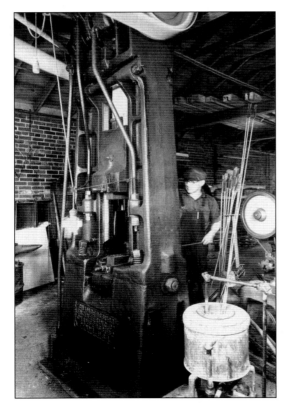

Frank Price (operating the razor forge, left) came to W. R. Case & Sons from Geneva Cutlery to work on the razor line. James Balistreri, Fred Carey, Pat D'Amico, and Frank Tascone also joined him at Case from Geneva.

Mary Rose Tascone was the daughter of Frank Tascone and worked at Case from 1937 until her marriage in 1941. This photograph with Russ Case was taken at an employee picnic. Russ held these picnics every year and made sure everyone had transportation to and from the party.

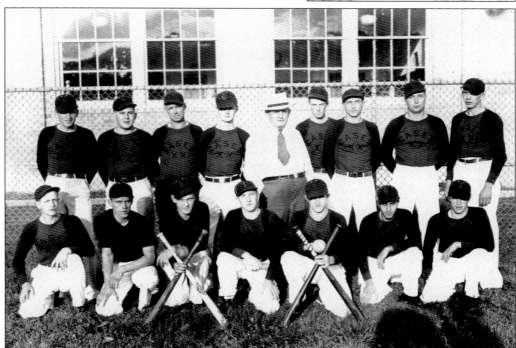

This is the 1937 W. R. Case baseball team. From left to right are (standing) Ralph Clark, Henry Strickenberger, Turk Cramer, Clair McBride, Russ Case, Clarence Gibbs, John Slotta, Jim Fuller, and Joe Petro; (kneeling) Al Higley, Bruce Ogden, George Spignard, Charley Crawford, Herb Gallup, Henry Therminy, and Bob Lutman. Of course, the bats are held in XX style.

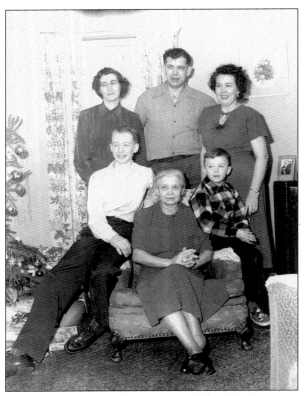

Christmas with the Petro family includes, from left to right, (standing) Mary Petro, Joe Petro, and Anna Petro Tingley; (seated) Bill Tingley, Anna Petro, and Jim Tingley. The Petros had an amazing commitment to Case. Anna Petro worked for 54 years and her daughter Mary, an incredible 70 years at Case.

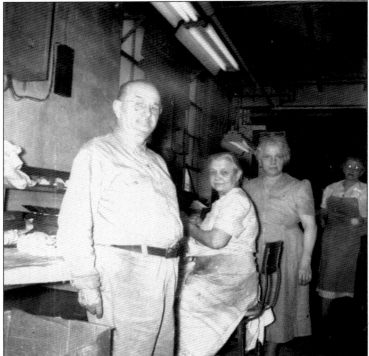

Wareroom foreman Dolly Bryant is pictured with Anna Petro and two of her coworkers Mary and Mina.

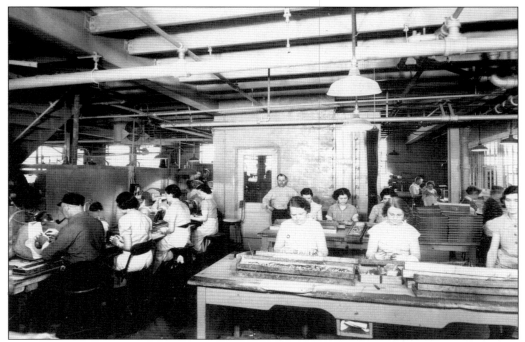
Another Wareroom photograph shows Mary Petro in the front right. The Wareroom was the department where the honing, cleaning, and packing of the ware (knives) was completed.

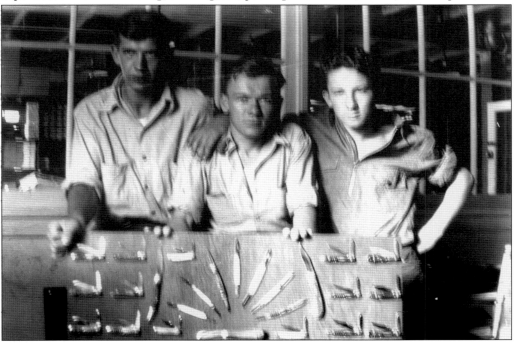
From left to right, Joe Petro, Steve Simcoe, and Louis Graves are pictured with a display panel they had just completed. Wiring knives on these panels took (and still takes) extra care and a special eye.

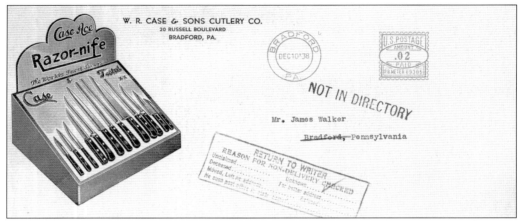

James Walker was hard to locate in December 1938, but the postage was only 2¢. Note the Case Ace Razor-nife display image used on the envelope.

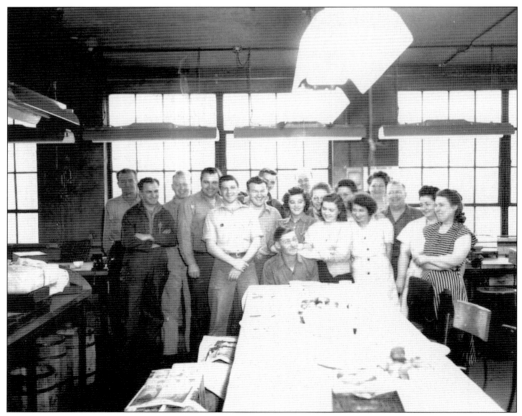

It was not unusual (and still is not for that matter) for a department to celebrate someone's birthday or other special occasions. This birthday party is in the Shipping Department.

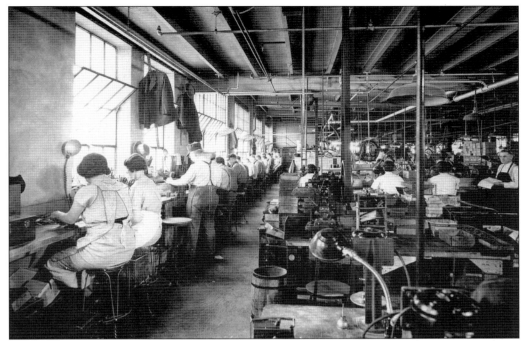

These are cutlers. Working with the utmost skill, the cutler fine-tuned the pocketknives, making slight adjustments to insure the blades would snap open and closed, or "walk and talk" as the folks at Case like to call it. The cutlers' work was all part of the handcrafting that went into, and still goes into, a Case knife.

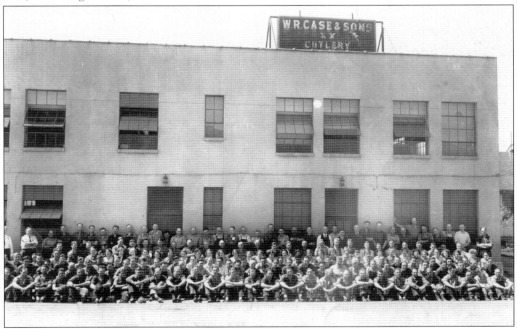

This is a photograph of the Russell Boulevard employees from the late 1930s. Notice the lady in the window who did not want to join the rest of the group.

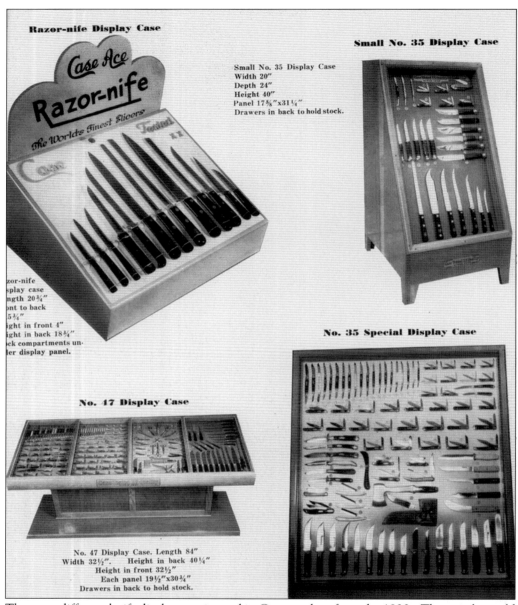

These are different knife displays as pictured in Case catalogs from the 1930s. The panels would be updated as needed when there were changes to the product line. Some of these displays can still be seen at Case dealers today.

There were many levels to Russ Case. With a wide variety of interests, from horses to farming, he even ran a hotel in Lilydale, New York. A free-spirited thinker with a great sense of humor, Russ was a man ahead of his time.

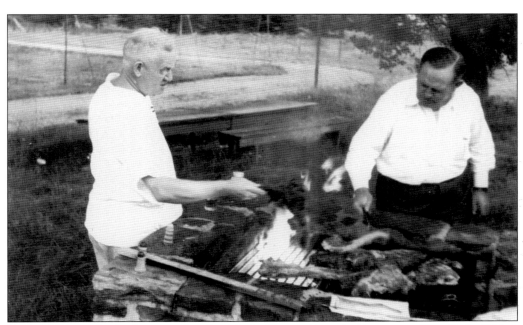

Russ takes over the barbecue grill at his Maple Groove Farm in Limestone, New York. Walter Scott, a hardware distributor salesman for Hibbard Spencer Bartlett, is his guest.

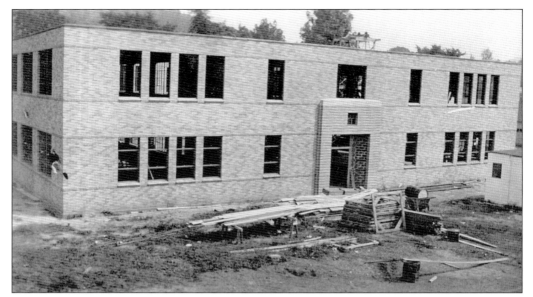

This is a photograph of the Russell Boulevard office building under construction in 1941. Ironically, the office equipment, furniture, and records were moved into the new building on December 7, 1941. That Sunday was the attack on Pearl Harbor, which brought the United States into World War II.

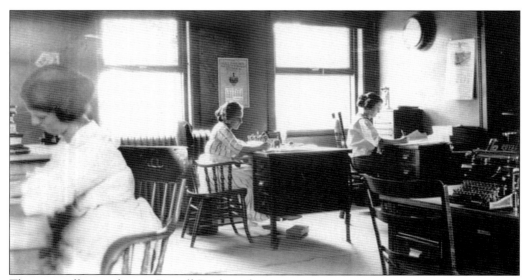

These are office workers at Russell Boulevard.

W. R. CASE & SONS CUTLERY COMPANY
SINCE 1889
TESTED XX
MANUFACTURERS OF QUALITY CUTLERY
BRADFORD, PENNA.

January 1, 1943

TO ALL W. R. CASE & SONS CUSTOMERS:

First, allow us to thank you for the cooperation that you have given us in the past and especially under the trying conditions of 1942. We have done the best we could to take care of you.

The beginning of the new year finds us in a rather bad condition to supply our trade with cutlery, at least for a while. The blunt facts are that we are not able to supply any civilian cutlery at the present as our stock is depleted.

We have received no new ruling from the Government as to what they are going to allow us to make for the civilian trade, and until this order is received we are helpless to give you any definite information as to what we can do for you in 1943. If this ruling is favorable and we are allowed to manufacture a certain quantity of goods for the civilian trade, we will immediately notify you when we are in a position to accept orders from you. The best that we can expect is that this will be very limited. The Government is requiring an enormous quantity of cutlery in various departments. We are doing just what you would want us to do — turning our efforts to help win the war.

It is not pleasant for us to ask you not to send us any orders for the present, but we must. We simply cannot accept them. As soon as we are able to supply you again we will advise you promptly. We will not forget that our most valuable asset is our customers and we ask that you bear these conditions with us for the present. We hope it will not last long.

We are mindful of the fact that in order for our customers to stay in business they must have merchandise and we trust that the Government will realize these facts and make it possible for us to do our part in supplying the Government as well as assisting our customers.

You will hear from us again as soon as it is possible for us to furnish you some merchandise.

With best wishes for a Victorious New Year, we remain

 Yours very truly,

 W. R. CASE & SONS CUTLERY COMPANY

 J. Russell Case
 President & General Manager

JRC:DM

Russ Case sent this letter to Case dealers in January 1943, explaining W. R. Case & Sons's production would be dedicated to the war effort so he would be unable to fulfill any of their orders.

In 1945, W. R. Case & Sons employees were awarded the Army-Navy Production Award for their contributions to the war effort. The presentation ceremony included the raising of the Army-Navy E flag, with Case employees Emmett Maben and Vice Pres. Harlan Barnard accepting the award on behalf of the company. All Case employees were awarded Army-Navy E pins.

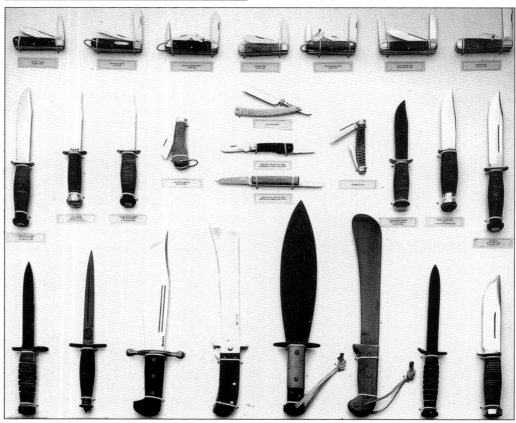

These are examples of the pocketknives, razors, machetes, M3s, and other combat knives manufactured by W. R. Case & Sons during World War II. Probably the most famous of these wartime knives is the V-42 Stiletto (bottom row, second from left) produced for U.S. Army Special Forces.

With gasoline and tire rationing in place during World War II, Russ Case purchased an automobile to provide transportation to work for his employees living in Bradford. He needed his workforce on hand to keep up with wartime production. This hafter was hand shaping the leather handle of a fixed-blade knife. Case still makes these the same way today.

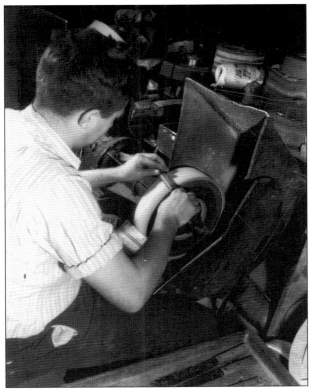

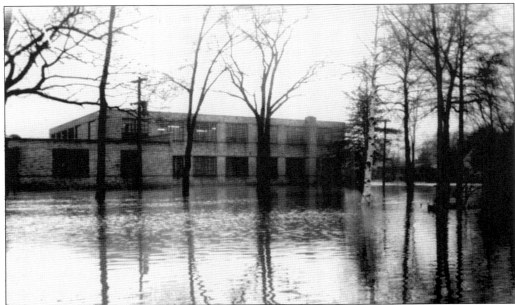

In the 1950s, Bradford completed a flood control program. Before that, the Russell Boulevard plant suffered two floods. In 1942, the Tunungwant Creek overflowed its banks, flooding the plant for the first time. After the floodwaters receded, there was a 6-foot-wide, 10-foot-deep hole in the floor of the Press Department.

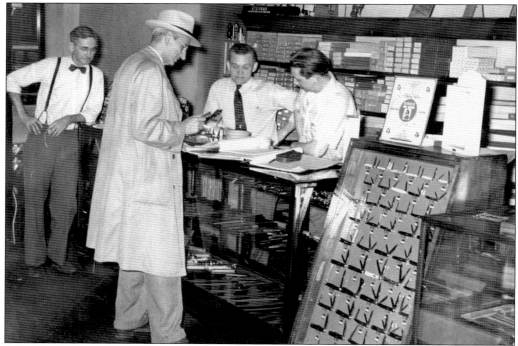

Ernie Wusthof was a salesman for W. R. Case & Sons for many years. Here he makes sales calls on retail (above) and hardware (below) stores.

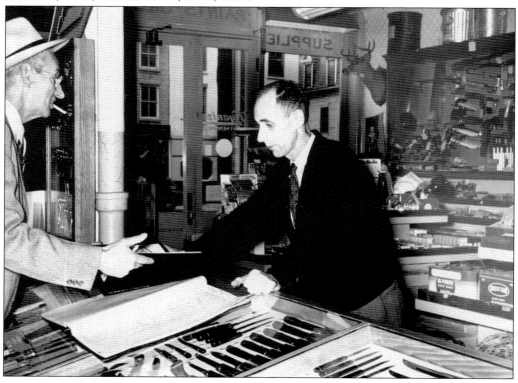

Wusthof is shown here at his home in Perry, New York. He stayed with Russ Case and worked in the factory during World War II.

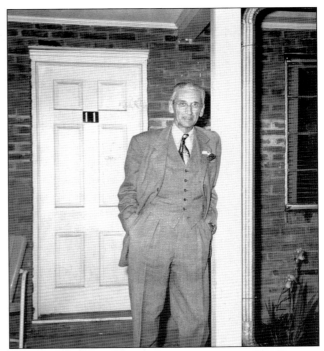

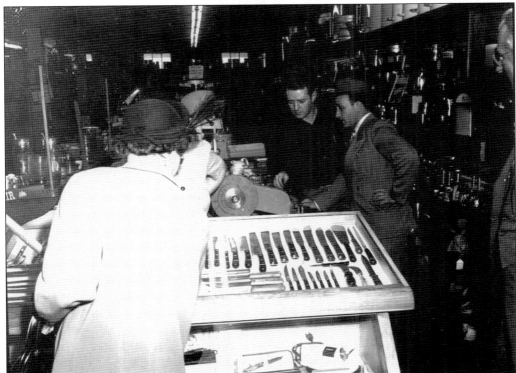

Case salesman Ernie Wusthof waits while Dean Case of Kinfolks makes a presentation at a hardware store.

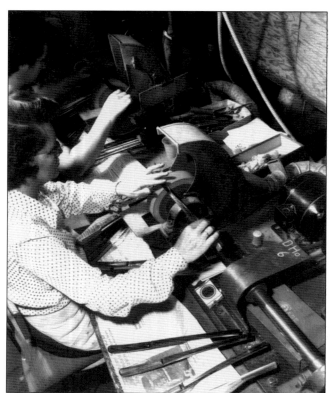

These bread knives are being honed to a razor-sharp edge on a stone wheel. It took a steady hand and still does.

The February 1948 edition of *Case Tested XX News* paid tribute to the Cramer brothers for 100 years of service to Case. From left to right are Charles, Clarence "Knute," Frank "Turk," and Jack Cramer. All were skilled employees, working in the Finishing Department where Turk was the foreman.

Case sales representative A. D. Branon explains the finer points of a Case carving knife to a buyer from Woodward and Lathrop.

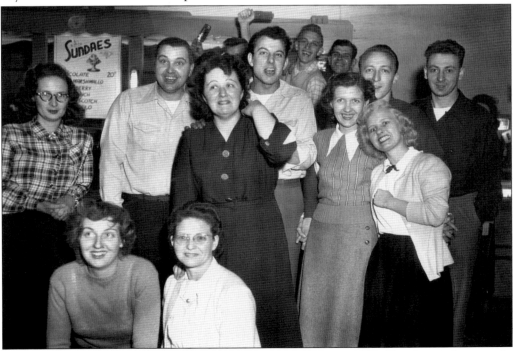

It looks like all are having fun at this Case roller-skating party in 1949. Kneeling in front are Jo Graves and Alice Bernard. The ladies standing from left to right are Dorothy Oliver, Di Folts, Mrs. Leo Kornacki, and Mrs. Ray Ness. The gentlemen standing from left to right are Fred Woodruff, Joe Tasin, Dick Austin, Charley Flicker, Leo Kornacki, and Ray Ness.

Russ Case (right) and Al Branon relax at Berghoff's restaurant in Chicago after a hardware show. Standing in the background is Russ's friend Ingo Preminger.

Another shot from Berghoff's includes (clockwise from left) Brian Hightower, John O'Kain, H. I. Prater, Al Branon, Russ Case, and Al Rosenberg.

The Signature Line of household knives, introduced in Chicago in 1949, was among the most beautiful W. R. Case & Sons ever produced. The innovative Double Concave ground stainless blades showcased the skill and expertise of the Concave Grinding Department.

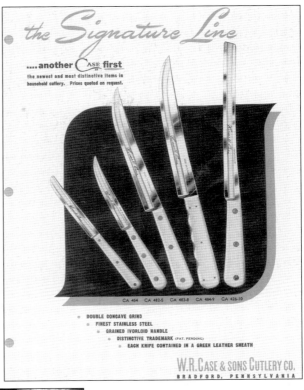

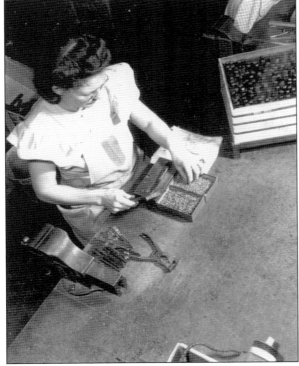

Monti Detar rivets the handles onto what appear to be the 283 pattern steak knives.

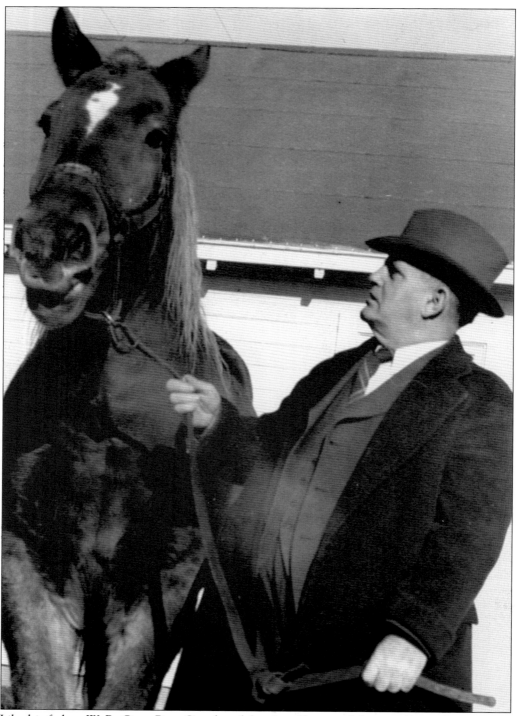
Like his father, W. R. Case, Russ Case loved farming. He owned farms in Pennsylvania, New York, and Arkansas where he kept cattle, hogs, and horses. He is pictured here with one of his prize horses.

Harry Slefkin was one of Russ Case's best friends. An interesting character, Slefkin always had some sort of "deal" he was working on with Russ. This picture, taken at the Harry A. Slefkin Farm in Arizona, includes (from left to right) Case, John Berg, and Slefkin among the horses.

Standing from the left in this photograph are John Russell Osborne Sr. and John O'Kain. Seated from left to right are Harlan Barnard, Russ Case, and Guy Rhodes, who was the company treasurer. The oval picture is of Florence Case's mother.

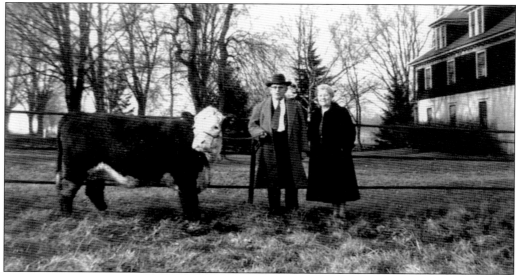

Russ Case and his second wife, Florence, admire their prize-winning bull at Russ's Red Bird Farm in Sinclairville, New York.

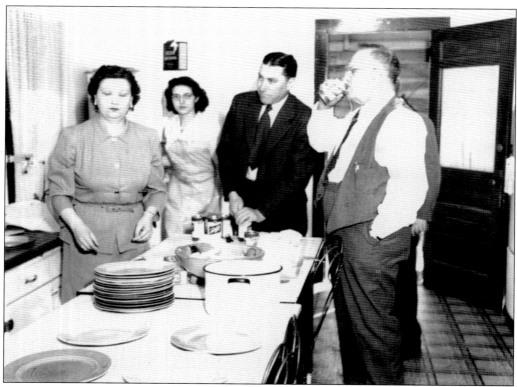

Russ Case loved spending time at his farm in Limestone. This was the kitchen, with Frances Giancotti (left) and Harry Slefkin next to Russ. The lady in the back is unidentified.

Maple Grove Farm was the name of Russ Case's dairy farm in Limestone, New York. Note that the XX logo is used on milk bottles as well as Case knives.

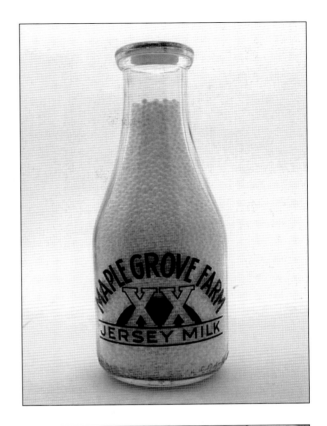

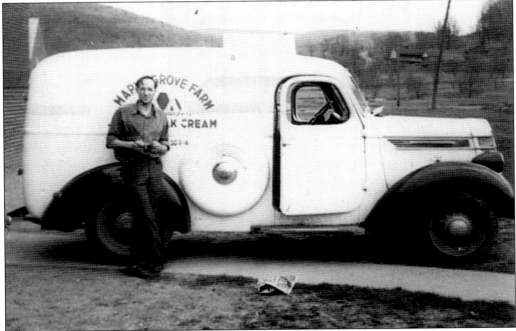

A Maple Grove dairy truck delivers milk to the Derrick City School. This is the school custodian.

Russ Case and his older sister Theresa Crandall were very close. From sitting on the W. R. Case & Sons Board of Directors to simply being a big sister and confidant, Theresa was always there for her brother.

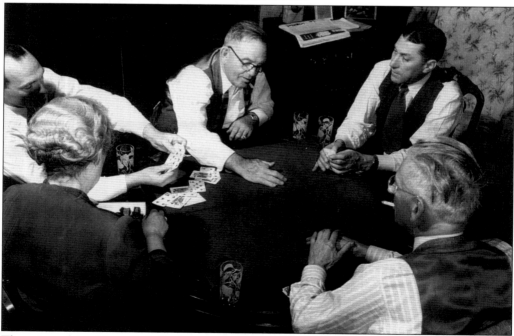

There is nothing like a little business around the card table. The players for this game at Russ Case's house include (clockwise) Russ, Harry Slefkin, Ernie Wusthof, Florence Case, and a buyer from New York. Russ was known to get a bit cantankerous at these games. He might fire a salesman or someone by the end of the evening, of course hiring them back the next day.

At the Case Christmas party at the Pennhills Club in Bradford, it looks as though Russ Case is standing to say something important. Knowing Russ's sense of humor, it is just as likely that he was picking on Lucille DePalma, who was seated to his right.

Louis Graves is at the center of this picture from a late-1940s New Year's Eve party. He was the nephew of Russ's wife Florence and lived with them, working at the Case factory until the outbreak of World War II. After the war, Graves served as the Case pilot, as personnel manager, and later as a sales representative.

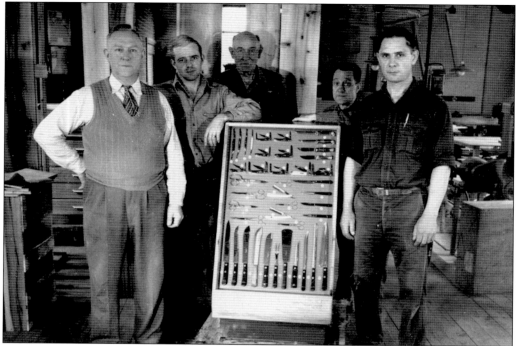

Hilding Olson managed the cabinet shop at Russell Boulevard for many years. Pictured with a completed knife display cabinet are, from left to right, Olson, Phillip Price, Dell Case, an unidentified employee, and Sylvester Lucas.

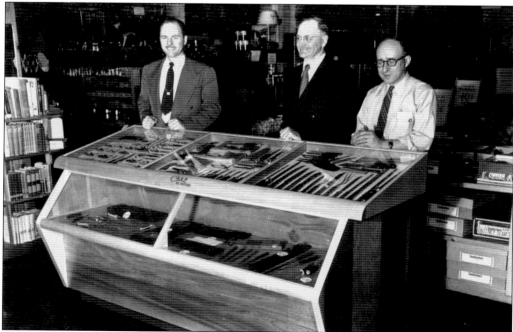

Another example of the incredible craftsmanship of the Case Cabinet Shop, this Case No. 48 display is pictured in a hardware store.

Case personnel director Louis Graves was responsible for publishing the employee newsletter, *The Case Tested XX News*. Working with Graves was a team of reporters from every area of the factory: concave, finishing, machine shop, wareroom, butcher department, material room, and so forth. Special events and activities were covered, along with news from sales, shows, and some good-natured ribbing of employees.

The first Case XX Turkey Shoot was held in 1947 at the Maple Grove shooting range on Russ Case's farm. Prizes included 12 turkeys, a carving set, and a Knife-Ax combination set. John Slotta had the best shot of the day, hitting the target X in the exact center. Shooting was conducted into the night with Herman Fisher running his car headlights so the target could be seen.

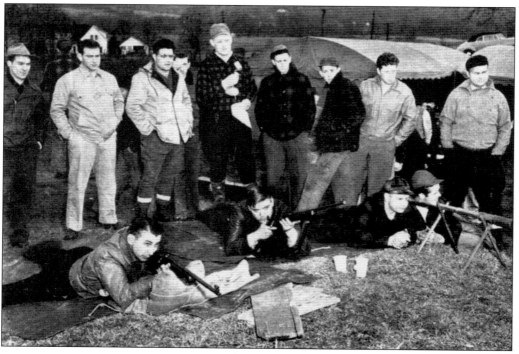

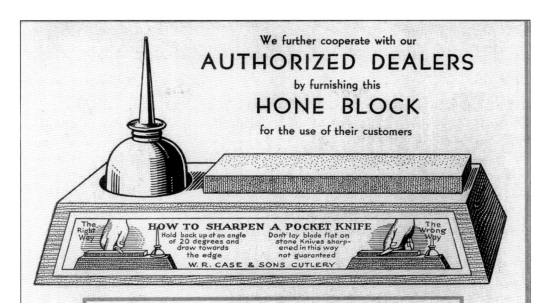

Case authorized dealers were provided a hone block, allowing customers to sharpen their pocketknives any time they visited the store. This guarantee page was printed in early Case catalogs.

This is an aerial photograph of the Russell Boulevard plant from the 1940s. Houses and a ballpark can be seen at the top of the picture above the Tunungwant Creek. The Case property starts after the oil tanks and railroad tracks. Factory buildings start with the Quonset hut (left) and main factory building (with bone room and old forge shop behind). The L-shaped building held the

cabinet shop and shipping areas. The office building was on the right. The road leading back into the factory is appropriately named Russell Boulevard. Russ Case liked to live close to the factory. His home was the fourth to the right of Russell Boulevard on East Main Street. Robert L. "Bob" Farquharson lived in the second (white) house, and Rhea Osborne O'Kain lived in the third.

J. Russell Osborne Sr. and great-uncle John Russell "Russ" Case are at Russ's farm with baby John R. Osborne Jr. and Spike. Russ did not have any children of his own and always considered Rhea Osborne O'Kain (J. Russell Osborne's mother) and her family as his daughter and grandchildren.

This was another picture taken the same day. From left to right are Betty and J. Russell Osborne with son John, Spike, Florence Case, Rhea Osborne O'Kain, and Russ Case.

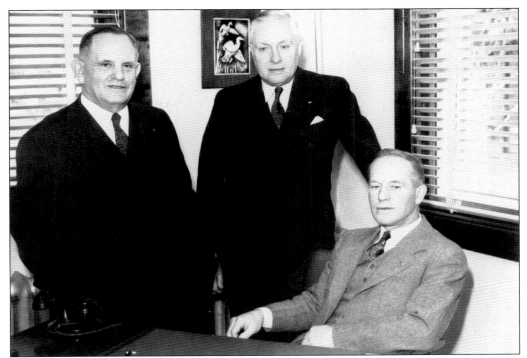

This picture was taken during a trip Russ Case took to Boulder, Colorado, to visit his sister Debbie Platts. Russ (left) is shown with Debbie's sons Harlow and Reginald Platts, from Western States Cutlery Company.

In 1948, W. R. Case & Sons purchased the Pictou Cutlery Company of Pictou, Nova Scotia. The newly established W. R. Case & Sons Ltd. would produce knives for the British and Canadian Navies. This venture proved disastrous, as much of the workforce would leave the factory during the peak fishing and lobster season.

W. R. Case & Sons operated a separate factory, the Case Shear Corporation (above), based in Nashville, Arkansas. Scissors and shears like those shown below were an important part of the Case line. They would be manufactured in the Nashville plant and then shipped to Bradford to go out in customers' orders.

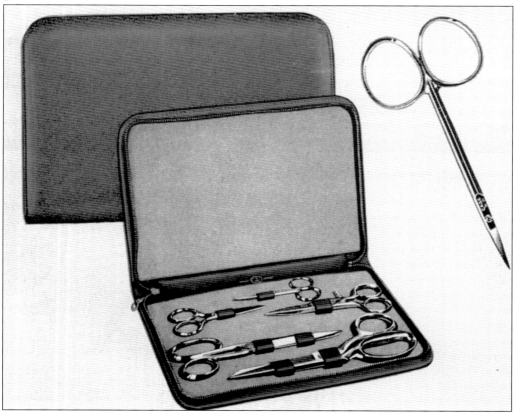

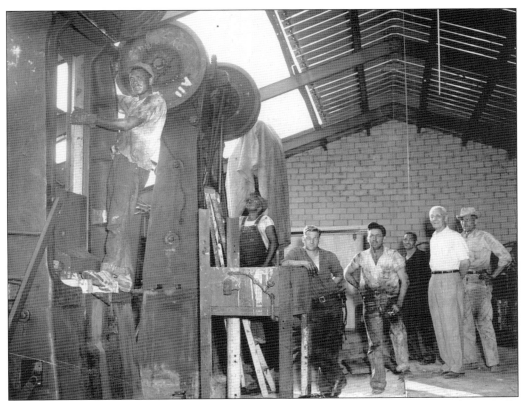
Workers install the forge at the Case Shear Corporation's Nashville, Arkansas, plant. W. R. Case & Sons also operated a second pocketknife assembly plant in Nashville until 1975. Parts were made at the Russell Boulevard plant and finished at the Case Nashville plant. Completed pocketknives were sent back to Bradford.

This sign was on the Russell Boulevard office building.

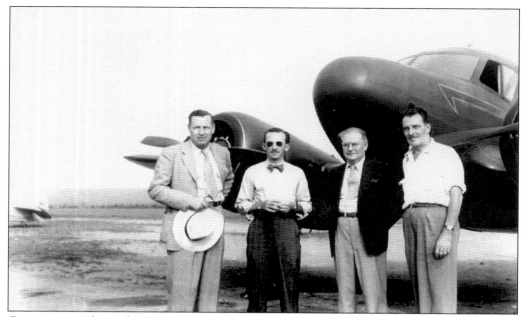

Case vice president John O'Kain, pilot Louis Graves, Will Adams of Adams Plastics Company, and Case hafting foreman Mickey McBride pose for this shot in front of the Case Cessna at the Holyoke, Massachusetts, airport. Adams invented and patented the Pakkawood handle material first used by W. R. Case & Sons on household cutlery.

It is hard to tell whether Louis Graves's daughter Sharon (left) believed the story being told to her by young John R. Osborne Jr.

Bradford was a major oil-producing area, and there were several wells on Russ Case's property. It was Frank Grader's (above) job to take care of them. Faithfully checking and pumping the wells twice a day. Grader was always seen with that wrench in his left hand.

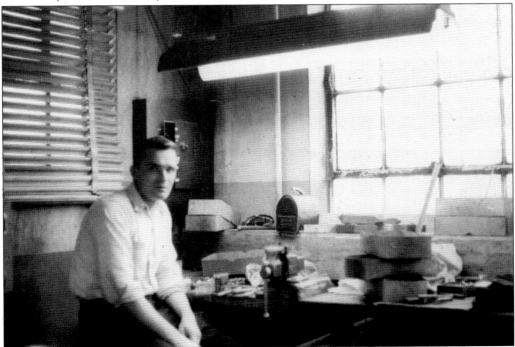

Tom Hart is pictured at his workbench at the Russell Boulevard plant. Hart was a master craftsman. Working for 50 years, he designed some of the most famous pocketknives in W. R. Case & Sons's history.

John O'Kain is leaving the Russell Boulevard office for the factory. With a degree in geology, he first came to Bradford to work in the oil business. O'Kain met and married Rhea Crandall Osborne after the death of her first husband, Harold Osborne. Rhea's uncle Russ Case convinced O'Kain to work for him at W. R. Case & Sons. O'Kain brought a real business sense to the company and was a tremendous leader. He would later serve as company president and retire as chairman of the board.

In 1948, Case and Alcoa formed Alcas (a combination of both names), a new corporation based in Olean, New York. The Alcas factory produced a line of household cutlery to complement Alcoa's Wearever brand of cookware. Alcoa held 51 percent ownership but left management responsibilities to W. R. Case & Sons. John O'Kain served as president of both companies, working at Case in the morning and then making the 18-mile drive to the Alcas factory in the afternoon.

Guy Rhodes (seated), treasurer, and J. Russell Osborne, vice-president, work a trade show, most likely the Housewares Show in Chicago. Osborne had worked in the Case factory as a young man, before entering the service during World War II.

Lucille DePalma worked in the office at Case, but she was more like a family member than a Case employee. She is in the center between Florence and Russ Case.

J. Russell Osborne sent a congratulatory letter and gift to General and Mrs. Eisenhower following the 1952 election.

```
                                        December 17, 1952

General and Mrs. Dwight D. Eisenhower
60 Morningside Drive
New York, New York

Dear General and Mrs. Eisenhower:

We realize that you are very busy people but did want to take
this opportunity of expressing our joy over your election and
the consolation it will be to have you as our President and
First Lady of the Land.

Also we are sending you under separate cover a set of pearl
handled steak knives manufactured by our concern which we hope
you may realize some pleasure from.

With all good wishes for the coming holidays!

                        Yours very truly,
                        W. R. CASE & SONS CUTLERY COMPANY

                        J. Russell Osborne
                        Vice-President & Assistant Treasurer

JRO:mlr
```

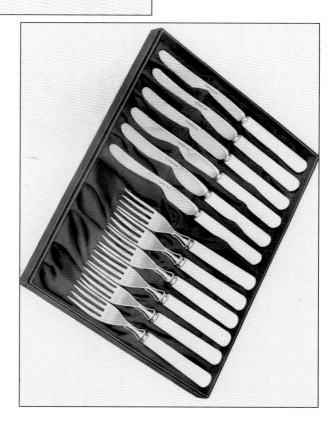

These are examples of some of the beautiful flatware produced by W. R. Case & Sons at the time of Pres. Dwight D. Eisenhower's election.

This is Mamie Eisenhower's reply to J. Russell Osborne.

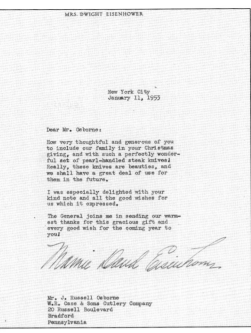

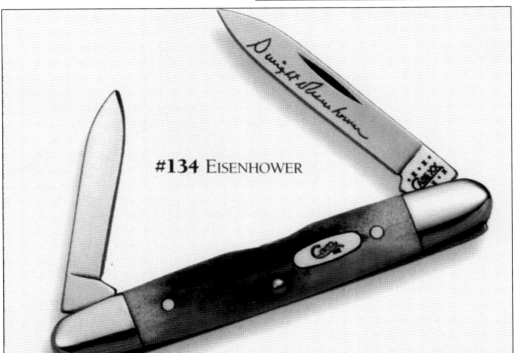

President Eisenhower's favorite Case knife was the 05263 gentleman's penknife. He liked to give them as gifts, purchasing them from a Case dealer in Texas and having them engraved. When Case found out about this, they offered to provide him with knives directly. Eisenhower would not hear of that, wanting to still support that dealer in Texas. The knife above is now known as the Eisenhower and features the president's signature.

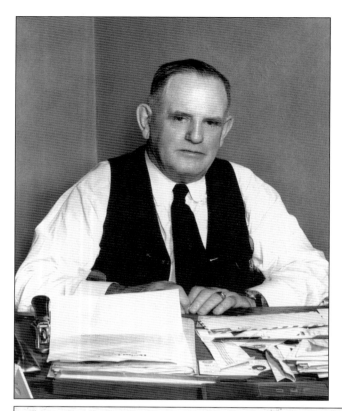

John Russell Case would lead his company for more than 50 years. Under his steady hand, Case would build knives for servicemen in two world wars, survive the economic upheavals of the Great Depression, and grow to become the dominant American manufacturer of cutlery and handmade pocketknives.

> With profound sorrow we announce the death of
>
> Mr. J. Russell Case
> Chairman of the Board
>
> on Wednesday, September the sixteenth
>
> Nineteen hundred and fifty-three
>
> W. R. Case & Sons Cutlery Company
> Bradford, Pennsylvania

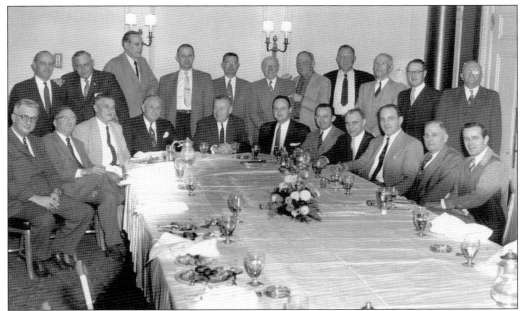

With the passing of Russ Case, John O'Kain was named chairman of the board, and J. Russell Osborne became president. The photograph above, taken at Chicago's Palmer House, includes, from left to right, (first row) Ralph Foster, Brian Hightower, J. C. Sanders, Al Branon, John O'Kain, J. Russell Osborne, Louis Graves, Dave Bauer, R. N. Farquharson, Howard Martin, and Phil Price; (second row) Loren Horner, Ben Corley, Rex Goble, Frank Gerard, Bryan Galloway, Hank Barber, Walter Lewis, Bill Lewis, J. C. McColloch, Joe Files, and Al Rosenberg. In the photograph below, sales representatives Louis Graves (Minnesota, Wisconsin), Bob Martin (Louisiana), and Bob Farquharson (New York, Michigan) meet with Case president J. Russell Osborne.

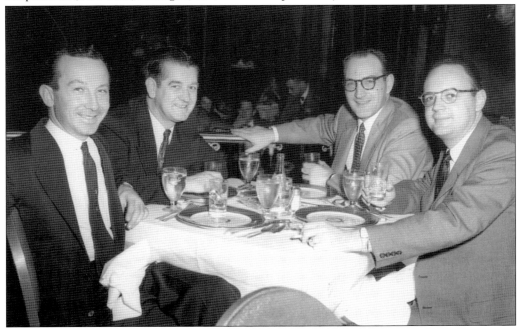

Harold "Skinny" Fisher stands by the Induction Annealer. It was described in Case catalog No. 66: "Realizing the importance of properly annealing pocketknife blades, Case, in cooperation with one of the leading manufacturers of electronic equipment developed this modern induction type annealing furnace . . . extremely efficient and highly effective in increasing the strength of Case pocket blades." The controlled-atmosphere hardening furnace (below) was also described in the same catalog as "the finest known method for heat-treating steel, and is one of the major reasons for the incomparable quality of Case blades."

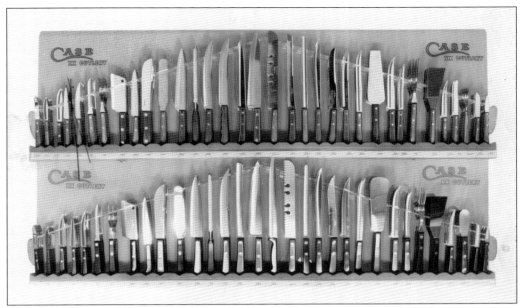

From paring knives, to cleavers, to a knife designed for cutting frozen food, the panels above show the wide array of cutlery offered by W. R. Case & Sons. Case dealers also continued to be provided with new and innovative displays like the No. 60 BGT shown below.

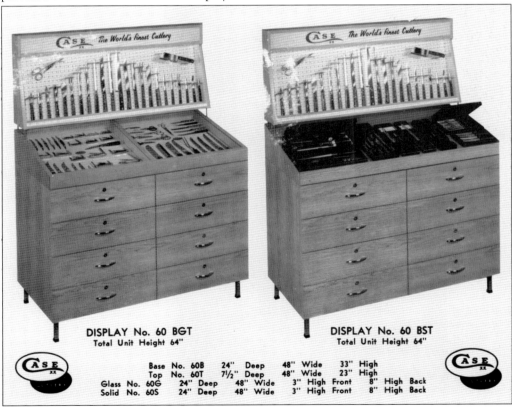

DISPLAY No. 60 BGT
Total Unit Height 64"

DISPLAY No. 60 BST
Total Unit Height 64"

Base No. 60B	24" Deep	48" Wide	33" High			
Top No. 60T	7½" Deep	48" Wide	23" High			
Glass No. 60G	24" Deep	48" Wide	3" High Front	8" High Back		
Solid No. 60S	24" Deep	48" Wide	3" High Front	8" High Back		

John R. Osborne Jr. and his pet bulldog, Sam, are in the photograph above. John started working for W. R. Case & Sons when he was in high school. His father, J. Russell Osborne, had him taking inventory in the stockroom over Christmas vacation and mounting knives on display boards with Joe Petro in the summer. Sam the bulldog became famous in his own right, as he inspired the blade etching on the 5172 shown below.

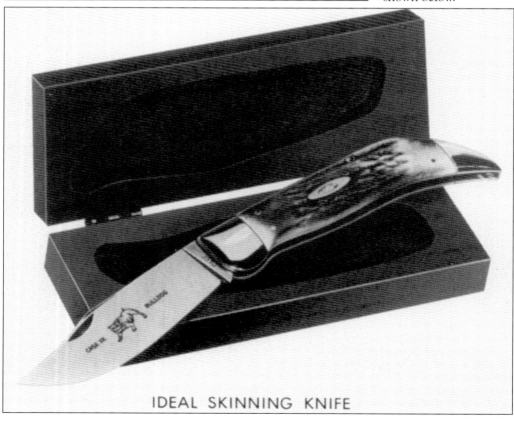

IDEAL SKINNING KNIFE

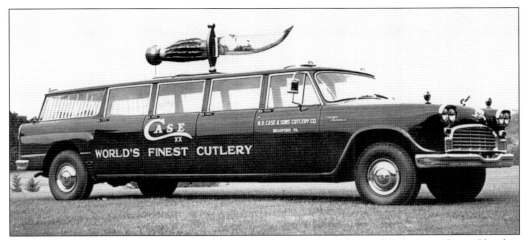

If employees needed a ride to work, they could arrive in style in the famous Case Checker Aerobus. The eight-door limousine was purchased in 1965 and fitted with a giant model of the Kodiak Hunter.

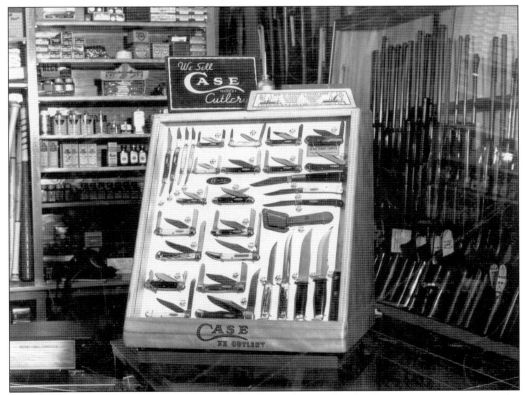

Case salesmen would work with their customers, tailoring the display assortment to meet the needs of that particular store location. Notice this display from the early 1970s featured more hunting knives, fishing knives, and larger folders—no household cutlery for this gun shop.

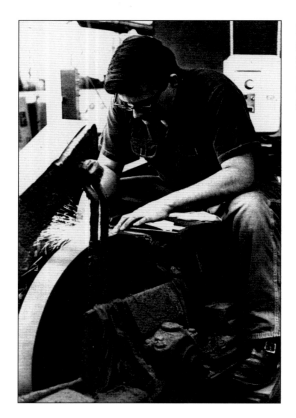

Ralph Banks, Case associate since 1966, is hand grinding a Bowie blade on the big floor wheel in the Grinding Department. Banks is an artist at grinding blades, carrying on the tradition of previous generations of Case craftsmen.

Neil Armstrong poses with a commemorative version of the Astronauts knife W. R. Case & Sons produced for NASA. Case Astronauts knives were carried on all Gemini and Apollo missions, including Armstrong's mission to the moon.

Opera singers Patrice Munsell and Robert William Wright were playing leads in *The Merry Widow* at the time they stopped by the Case booth at a trade show.

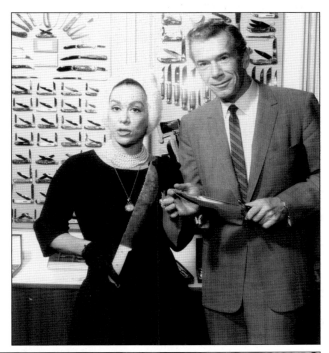

In 1972, W. R. Case & Sons Cutlery Company was sold to American Brands, the corporate giant whose other holdings included Master-Lock and Titleist. While the Case family gave up ownership, they did continue to manage the company, with J. Russell Osborne staying on as Case president. In the image above, Bob Farquharson presents American Brands president Jack Behr with an Astronauts knife at his retirement dinner.

John Lombardi (standing left) receives a service award from Case vice president Ron Coburn. Seated are Charles Little (left) and Al "Jim" Antese.

The directors of the Case Nashville, Arkansas, pocketknife assembly plant are pictured as follows: (first row) Judge Steel, J. Russell Osborne, Hank Therminy, and John O'Kain; (second row) Ray Utley, John Spignard, and Jet Sain. W. R. Case & Sons closed its Nashville pocketknife assembly plant in 1975.

Five
South Bradford Factory

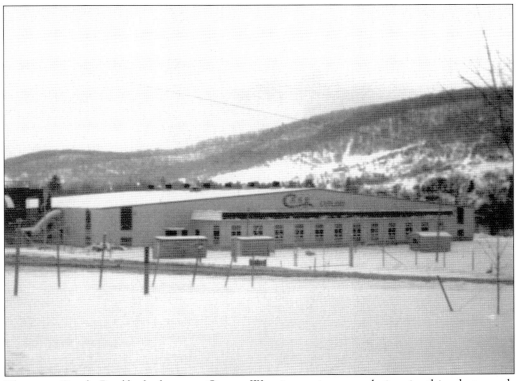

The new South Bradford plant on Owens Way is nearing completion in this photograph from February 1975. While American Brands had made upgrades to factory equipment at the Russell Boulevard factory, helping productivity and improving safety, capacity continued to be a problem. Shifting pocketknife production to this new facility, with household and hunting knives at the old plant, would give W. R. Case & Sons room to grow.

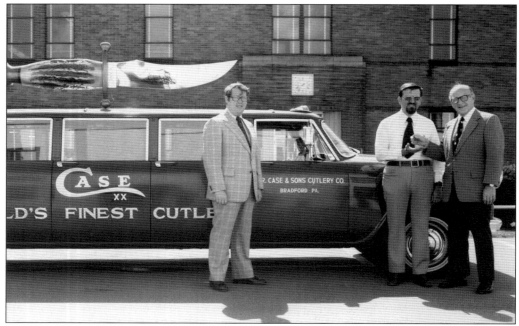

In 1976, W. R. Case & Sons donated the Case Checker Aerobus to the Bradford Children's Home. Tom Urban (center), director of the children's home, accepts the keys from John R. Osborne Jr. (left) and Bob Farquharson. The Case Kodiak was moved from the car to the sign in front of the Owens Way factory.

W. R. Case's sales force was in town for a meeting in 1977. Pictured from left to right are (first row) Joe Files, Yancy Pleasant, Bob Noel, Warren Massey, Bill Clark, Jake Leonard, Steve Matterson, John R. Osborne Jr., Jack Schreier, Bob Farquharson, Bill Galey, Bill Derby, Bruce Gerber, and Frank Lockett; (second row) John Montgomery, Lois Delevan, Bill Wilson, Frank Gerard, Larry Dokmo, Floyd Johnston, Hal Fairhurst, Paul Wild, Ken Bone, Don Reynolds, Fred Yeager, Mike Howey, Wally Kutcher, Lon Howey, Al Owens, Warren Hall, John Hester, A. V. Atkins, John Owens, Edward "Eddie" Jessup Jr., and E. L. "Shine" Jessup Sr.

This is yet another example of the loyal W. R. Case & Sons workforce. From left to right, receiving their 15-year awards, are Shirley Barrett, Mary Somers, Wayne Buchanan, Dorothy Hazzard, Dale Clark, Sabatina Lombardi, Robert Lamb, Donna Whitford, Anthonio Vigliotti, Al Hazzard, and Louis Domenech.

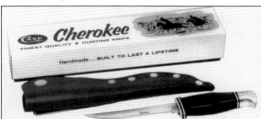

CHEROKEE 200

4¼" Saber ground, glazed finished, stainless steel, polished-edge blade. The same steel and cutting edge as the Astronaut's Knife (see page 43).
Genuine leather sheath handcrafted in heavy, top-grain cowhide carefully tanned to protect this fine blade. Each knife a precision perfect instrument, made by skilled craftsmen from special CASE formula American made steel.
Weight per standard pack of one is 11 ounces.

APACHE 300

5¼" Saber ground, glazed finished, stainless steel, polished-edge blade. The same steel and cutting edge as the Astronaut's Knife (see page 43).
Genuine leather sheath completely encases knife and held by an ultra-sturdy belt loop. Your personal knife won't be lost as you move through the heaviest brush.
Handmade and hand honed with an edge sharp enough to shave hair. Large comfortable and safe Hy-car handle.
Weight per standard pack of one is 12 ounces.

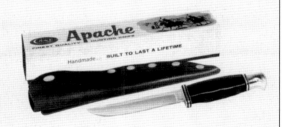

CHEYENNE 400

5" Oriental shaped saber ground, glazed finished, stainless steel, polished-edge blade. The same steel and cutting edge as the Astronaut's Knife (see page 43).
Genuine leather sheath in an exclusively handrubbed finish which makes each sheath an original. Fabricated with heavy nickel silver rivets—without a single stitch—to insure a lifetime of use.
This new razor-edge with its 5" hand ground stainless steel blade makes fast work out of dressing game. A superbly balanced hunting companion . . . "keen edged" and "sharp looking."
Weight per standard pack of one is 12 ounces.

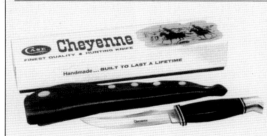

These hunting knives were part of the line in the 1970s.

Bob Farquharson (left), Case vice president of sales, and John Owens, Case sales representative, work a President's Day event at the Maas Brothers Department Store in Tampa, Florida. Farquharson may have started a trend, as Case still holds special President's Day events at authorized Case dealerships around the country.

This photograph was part of a press release to the newspapers in the Bradford area in June 1979. John R. Osborne Jr. (left) is with the packaging for the Case Double Eagle Bicentennial Bowie, which Bob Farquharson is holding in his hand.

In 1979, Brenda Brunner (now Blauser) started her tenure at Case, working as the receptionist of the South Bradford plant. She has taken on many responsibilities over the years and currently heads up the sales administration team.

Pictured from left to right, Clair Schattenburger, Ted Johnson, Ralph Banks, George Abrams, and Dave Southard, all from the Grinding Department, are participants in Case Hat Day. Case often holds special events to bring a little fun into the workplace.

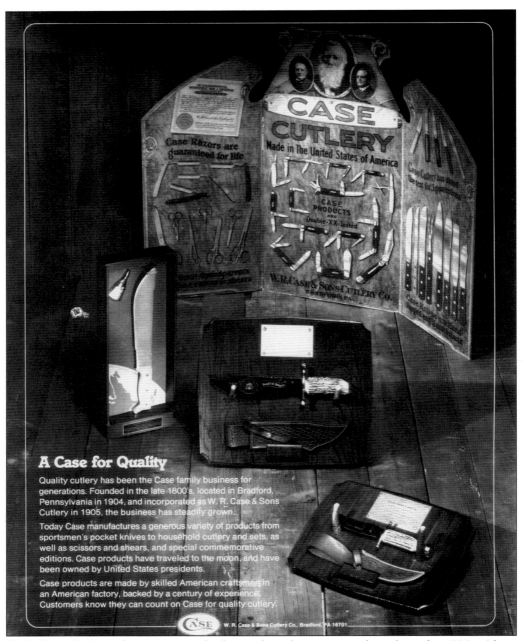

W. R. Case & Sons's heritage is on display in this advertisement sheet from the 1980s. Along with a vintage Case advertising piece and Astronauts knife, this sheet pictured a stag Bowie made for Pres. Ronald Reagan, and a Kodiak made for Sen. Howard Baker. When Case sales representative Eddie Jessup learned that President Reagan was a Case knife collector, he sought the help of Tennessee senator Howard Baker (who obtained the presidential seal used for the blade artwork) to put together a special presentation knife for the 40th president of the United States.

Pres. Ronald Reagan sent the thank-you note above to Case sales representative Yancy Pleasant regarding a Case knife he had received as a gift. The group pictured below built the special Bowie and Kodiak knives. From left to right are Tim Kaylor, who assembled the knives; John Maben, Ed Greek, and Chuck Ward, who hafted and buffed the knives; and Zana Verolini, who painted the etchings.

```
                    THE WHITE HOUSE
                       WASHINGTON

                              September 30, 1982

    Dear Mr. Pleasant:

    It was a nice surprise to be remembered with
    the specially engraved, handcrafted "Case"
    knife which I received through Lieutenant
    Colonel R. J. Affourtit. The workmanship
    is outstanding, and I really appreciate the
    time and skill which you and Mr. Roy Thel
    devoted to creating this gift for me. Thank
    you very much for your generous gesture of
    friendship.

    With my kind regards,

                              Sincerely,

                              Ronald Reagan

    Mr. Yancey G. Pleasant
    718 Park Street
    Charlottesville, Virginia  22901
```

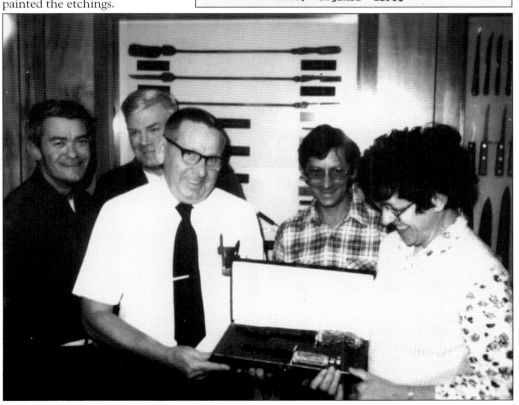

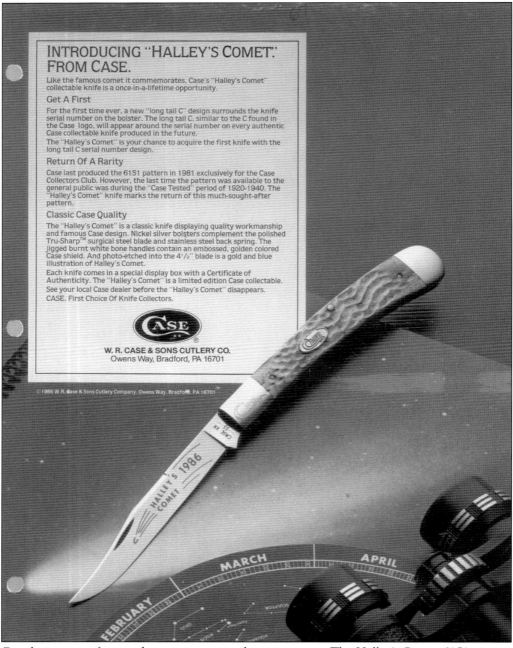

Case knives are often used to commemorate historic events. The Halley's Comet 6151 trapper knife was the first Case commemorative to feature the Long Tail C serial number engraving. This style of serialization is still used on all genuine Case collectable projects.

Toni Frontino assembles Hammerhead Lockback gift sets in back of the shipping area at Owens Way. Now, some 30 years later, there is still no way to adequately describe the energy and enthusiasm Frontino possesses. She is a dynamo and heads up the shipping and customer repair teams.

Bill Paulik (left) is with Mark Carinci at the Minster No. 5 press. The Minster was used for secondary stamping operations on hunter blades, guards, washers, scales, and other cutlery parts. Paulik started his career in 1971 and works in the Lock-Hunter completion module.

Starting his career in 1963, John Ruffner was the most senior Case associate in 2005 when this book went to print. He is assembling M3Finn hunters in this 1987 photograph. The leather washers that form the handle are slid into place. A fixture then holds the tang of the knife in a mold, where hot liquid metal is poured to form the knob. When the metal cools, the knife is removed from the fixture with the attached knob and can be hafted and finished.

Lenny Larson, Case associate since 1964, is pictured here working on a tray of knives at a polishing wheel. Removing the scratches and other imperfections still present after hafting and grease buffing, this polishing operation really makes the Case knives shine. Larson still does this wheel work in one of the pocketknife completion modules.

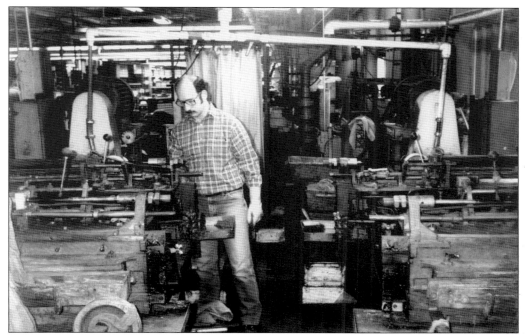

Dick Skillman is flat-taper grinding blades in this 1986 photograph. Two machines were used for a flat-taper ground blade, one for each side. Grinder operators manned four machines at a time, running two different knife-blade patterns. Skillman started at Case in 1965 and can be found on the fabrication side of the plant.

Donald "Whitey" Peterson is grease buffing a Case Bowie knife. Due to the shape of the guard, much of the hafting work on a Bowie is done to the handle before the knife is assembled. This grease-buffing operation takes a sure grip, as the wheel can catch the knife and pull it out of one's hands. Whitey, who has worked at Case since 1974, works on the consumer repairs team and acts as a tour guide for Case collectors visiting the factory.

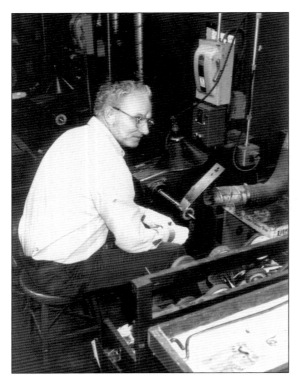

Dana "Goldie" Goldsmith uses a small 3-inch finishing wheel to color the shoulders (where the tang ends and the ground portion starts) of a blade. Hand operations like these are often done to knife blades, straightening grind lines, adding swedges (special grinds on the top of a blade) or other details. A few years after this photograph, Goldie made a valiant attempt to teach author John Sullivan how to haft a pocketknife. He retired in 2003 after more than 40 years of service.

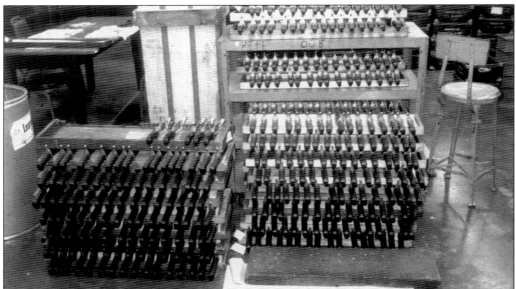

An order of Bowies is stacked in the "hafting cage," waiting to be completed. After assembly, the blades were covered with plastic wrap to prevent them from getting damaged. At the same time, the edges were covered with heavy tape to protect the hafter from getting injured. After hafting, the plastic and tape was removed and the knives transferred to the wareroom where the rest of the finishing operations were completed. These operations are now completed in the Lock-Hunter module.

Office space in the South Bradford plant was very limited, so an addition was added to the building in 1985. By the end of 1987, all operations moved from the Russell Boulevard plant to Owens Way. The giant Kodiak that was formerly on the Case Checker Aerobus can be seen on top of the sign.

The Kodiak mysteriously disappeared, only to be found two weeks later stuck in Jack Gorton's (standing with knife) yard, which was several miles from the plant. Since 1997, the giant knife has been safely on display in the museum at the Zippo/Case Visitors Center.

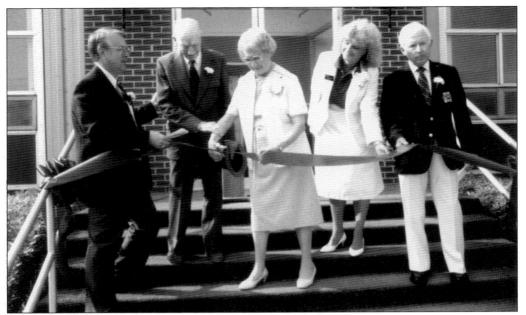

In 1989, after 17 years of ownership, American Brands sold W. R. Case & Sons to Jim Parker (left). To help celebrate, Parker hosted an anniversary event at the factory, honoring the Case family's 100 years in the cutlery business. Joining Parker, from left to right, are Case retiree Lester Bennett, who made pearl-handled pocketknives at the Bank Street factory; Mary Petro, the most senior Case employee with 65 years of service; Dolores Hatch, Case credit manager; and E. L. "Shine" Jessup, Case sales representative.

From left to right, Dan Wright, Louis Graves, and Jim Parker share a laugh after the 100th anniversary event. Wright came to Case from another of Parker's businesses, Cutlery World, a retail chain with stores in malls across the country.

The 100th anniversary was commemorated with the line of centennial knives and accessories. The knives, with stag, red bone, goldstone celluloid, or Christmas tree celluloid handles, featured a special 1889–1989 tang stamp and centennial blade etching

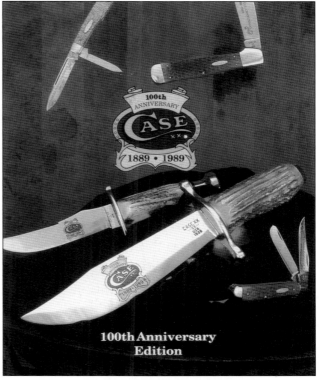

Someone snapped this picture in plant superintendent Dale Clark's office while he was checking some knives for etching with wareroom supervisor Erica Runyan. Standing from left to right are Clark, George Deming, and Runyan, with Fred Wickwire seated.

From left to right, Case credit manager Dolores Hatch and controller Deb Eddy give plant manager Ken Pashkow a hard time for not dressing in costume for Halloween.

Jim Parker's ownership of W. R. Case & Sons did not last for long. He ran into financial difficulties with his Cutlery World chain and Parker Cutlery Factory, eventually forcing Case into bankruptcy. Rivers & Associates purchased the company, with J. Melville "Mel" Armstrong taking charge. From left to right are Mel Armstrong, NASCAR driver Richard Petty, Don Haynes, Bob Scudder, Tom Radek, and Donnie Bowers at the 1992 SHOT (Shooting, Hunting, Outdoor Tradeshow) Show in New Orleans. Case did several projects with Richard Petty and other NASCAR drivers.

Rivers & Associates specialized in turning around troubled companies. By reorganizing, removing layers of bureaucracy, and instilling a new culture of empowerment, it would make them profitable and sell them. Employees at Case were now considered Associates. When Rivers had completed their turnaround efforts at Case, it looked to sell. It found the best possible buyer in another company also based in Bradford. Zippo Manufacturing Company acquired W. R. Case & Sons in May 1993. This commemorative set celebrated that historic union.

When Zippo purchased W. R. Case & Sons from Rivers, it asked George Brinkley, who had been operations manager, to stay on as president. The charismatic Brinkley developed a real rapport with both Case associates and Case collectors. In this photograph, Brinkley (right) and Zippo president Mike Schuler (left) make a presentation to Kevin Pipes, president of Smoky Mountain Knife Works, during a Case collectors event at Smoky's Sevierville, Tennessee, store.

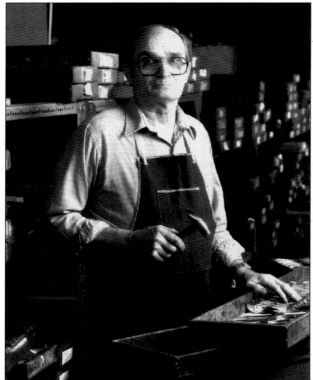

Famous Case knives like the Texas Lockhorn, CopperLock, Mini-CopperLock, and RussLock were all designed by Case model maker Tom Hart. Master craftsman may not do justice to Hart's skills as a knife maker; he was truly an artist. In his quiet and unassuming way, he inspired generations of Case knife makers to improve their craft. A Case legend, Hart passed away in 1999 with 50 years of service to the company.

The 1997 catalog introduced the CopperLock. The tagline was "One part trapper, one part copperhead, one part lockback—and 100 percent Case. Big job or small, a CopperLock handles them all." The CopperLock was the first new traditional pocketknife design offered by Case in years and was extremely popular with customers and Case collectors. The props in the photograph are tools from designer Tom Hart's workbench.

Case model maker Mike Dubois (left), marketing manager Lynn Golitz (right), and historian Shirley Boser (second from right) had the opportunity to meet singer and Case collector Randy Travis and his wife Elizabeth backstage during Travis's concert at the Chautauqua Institution in Chautauqua, New York. For several years, Travis was the "voice of Case," recording the on-hold phone message heard by folks calling the factory or sales office.

The holiday season is always an exciting time at Case, especially when Santa visits the factory bearing gifts. Santa, or Michael McLanahan as he is more regularly known, is the grandson of longtime Case associate Rose Hvizdzak. Santa stopped first at Case president Tom Arrowsmith's office to give Arrowsmith his traditional gift . . . a lump of coal!

Leeks are a favored springtime delicacy in the Bradford area. They have a fairly strong taste and aroma, especially when eaten raw. Merchants in East Bradford (near the old Russell Boulevard plant) hold a Leek festival aptly named Stinkfest, with an outhouse race as one of the events. Case associates Pat Pessia, Carla Hervatin, Ralph Barger, Shawn Whitsell, and Rob Freeman entered this masterpiece in the 2003 race.

Case associates built this float for Bradford's 2005 Memorial Day parade. Pictured from left to right are Jeanne DuBois, Carla Hervatin, Toni Frontino, and Ricky Deitz on the float. Associates' children and friends rode in the back of the truck. The Zippo Car followed in the parade.

W. R. Case & Sons has always been blessed with an extremely loyal and dedicated workforce. Pictured from left to right, members of the 2005 "25 Year Club" are (first row) Ritchie Mascho, Mike Fay, and Scott Freer; (second row) Sherry Southard, Shirley Barrett, Donna Whitford, Margaret Brocious, Sharon DuBois, George Deming, Betty Mack, Larry Saar, Linda Cranmer, and Lenny Larson; (third row) Dave Jack, Dianna Lewis, Shirley Boser, Brenda Blauser, Toni Frontino, Whitey Peterson, and Emmet Stiefel; (fourth row) Sue Griffin, Linda Sheridan, Julie Buchanan, Jeanne DuBois, Erica Runyan, Jacquie Lindquist, Donna Skillman, and Don Jacoby; (fifth row) Dale Clark, Robin Walker, Cheryl Lapallo, Mary Deming, and Tamra Shettler; (sixth row) John Ruffner, Dick Sheeley, Ken DuBois, Cal Abrams, Bill Paulik, Ralph Banks, and George Abrams.

Production manager Skip Lawrie (left) and engineering manager Rich Brandon (right) wish George Deming congratulations at his retirement celebration in 2005. Deming retired as the most senior Case associate, with 48 years of service. He had tried retirement before but came back to work. A skilled machinist, Deming built most of the fixtures used for knife assembly.

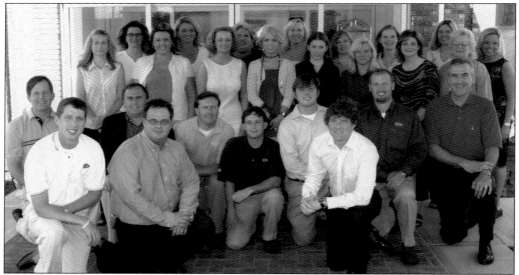

W. R. Case & Sons's sales force works out of the national sales office in Knoxville, Tennessee. Pictured, from left to right, at the 2005 sales meeting are (kneeling) Maury Ford, Paul Wilson, Eddie Jessup, Eric McNew, Doug Bryant, Will Heaslet, Dustin Vernon, Jason Burke, Kevin Anderson, and Nick Clancy; (standing) Michele Dehler, Mandy Jennings, Suzanne Hearon, Terri Alley, Denise Novak, Judy Johnson, Carrie Helle, Liza Hook, Alison Ashe, Staci Frantz (supply chain manager), Joy Howell, Amy Smith, Angie Perez, Holly Johnson, Pat Cox, and Kelly Noe.

Six

THE CASE COLLECTORS

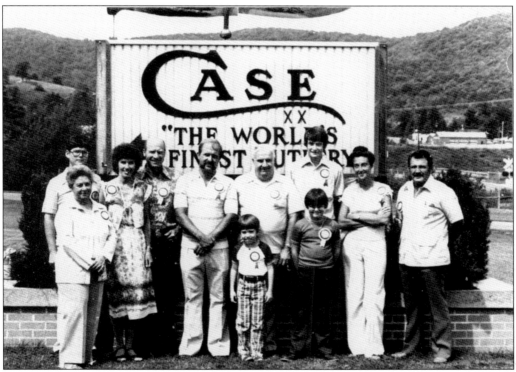

For some Case collectors, a trip to the factory in Bradford is like dying and going to heaven. Case eliminated the dying part, creating the Trip to Heaven promotion. Winners were judged by the National Knife Collector's Association to have the best Case knife collection on display at their sponsored shows. From left to right, collectors who made the first trip, in August 1979, are Mary Ellen Pumphrey, Doug Swancy, Nancy McElwain, Rich McElwain, Lee Becker, Jimmy Swanner, Bob Hemmick, Jimmy Huertas, Greg Hinton, Christine Shouse, and Ronnie Sizemore.

In 1981, W. R. Case & Sons started the Case Collectors Club and began publishing the *Case Collector's Club Newsletter*. Company president Bob Farquharson had long recognized the importance of knife collecting to Case's business. In this first newsletter, Farquharson wrote: "It is being published especially for our Most Important Customers . . . you, the Case Collector." By 2005, the Case Collectors Club had over 18,000 members and was the largest knife club in the world.

An annual club knife is offered each year exclusively to Case Collectors Club members. The first knife, in 1981, was the A6151 SS Appaloosa Bone Large Trapper. The knife featured an oval shield, Case Collectors Club blade etching, and also included an oval plaque. Starting in 1990, new regular, life, and junior membership classifications were added, each having their own exclusive knife.

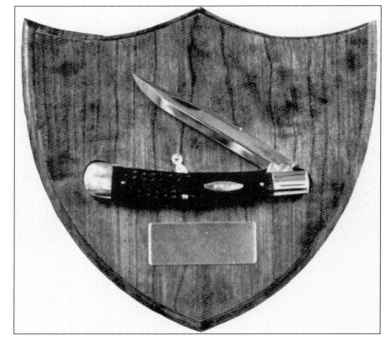

Dewey Ferguson was a pioneer in the field of Case knife collecting. As the author of several books on the subject, most notably *Romance of Collecting Case XX Knives*, published in 1972, he inspired generations of Case collectors. In appreciation of these efforts, Ferguson was named to the W. R. Case & Sons Cutlery Company Wall of Fame in 2001.

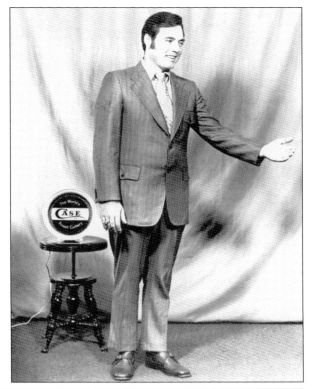

Jim Giles, pictured in his safety director's office at the Owens Way factory, wore many hats during his tenure at Case, including plant superintendent. Most of all, he was a great friend of Case collectors. He had the foresight to save things, gathering memorabilia, keeping for history what was otherwise headed for the trash heap. After retiring, Jim wrote *Case, The First 100 Years*, telling the history of Case from his interesting viewpoint inside the plant. He also served for many years as editor of the *Case Collectors Club Newsletter*.

Through the 1990s, Shepherd Hills Cutlery became a major customer for W. R. Case & Sons. They helped cultivate the interest of new Case collectors by marketing a wide variety of limited production knives, or "special factory orders" (SFOs). Shepherd Hills stores are owned and managed by the Reid family. Pictured in this photograph from the Zippo/Case International Swap Meet in 1997 are Rod Reid, Beverly Reid, Randy Reid, Ida Reid, and Rea Reid.

Each September, Shepherd Hills hosts the Case Celebration in the Ozarks at their Lebanon, Missouri, store. Thousands of Case enthusiasts spend a fun-filled day trading stories with fellow collectors, learning about the latest releases from the Case factory, and buying a knife or two. Case associates Katie Ludwig (SFO/special project manager) and Staci Frantz (supply chain manager) are certainly enjoying the day.

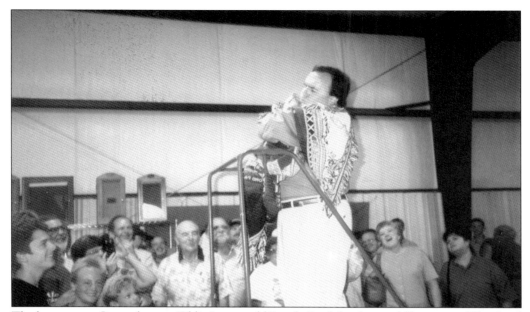

The bet was on. Case salesman Eddie Jessup told Randy Reid that he would kiss a pig if Shepherd Hills could sell out the inventory of Case afghans they had produced. When the last afghan sold, Jessup paid up, kissing the pig during the 1997 Case Celebration in the Ozarks. He and the pig were reunited the following year, and the pig did not seem too happy. Reid always liked a good joke, so barbecue was served at the 1999 Case Celebration.

An auction is held each year at the Case Celebration in the Ozarks, with proceeds going to support the Case Kids Camp. The camp is a great educational program started by Shepherd Hills and W. R. Case & Sons to benefit junior Case collectors. Hundreds of kids participate each year. In this photograph from 1998, Maury Ford displays a special auction offering while "auctioneer" Eddie Jessup works the crowd into a bidding frenzy.

At the grand opening ceremony of the Zippo/Case Visitor's Center and Museum in July 1997, company owners Sarah Dorn and her son George Duke cut the ribbon with a ceremonial Case Bowie while Barb Kearney and Blaise Wick look on. The Zippo/Case Visitor's Center (below) has become one of the most visited museums in Pennsylvania. Showcasing rare artifacts from these two great American companies, it stands as testimony to the tremendous support given to W. R. Case & Sons by their owners at Zippo.

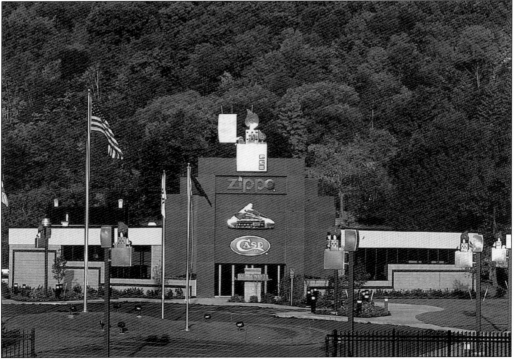

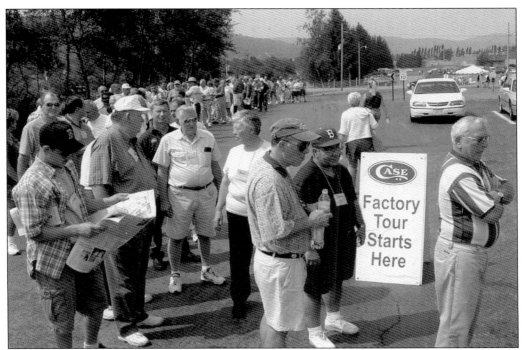

Every other July, thousands of Case and Zippo enthusiasts from around the world come to Bradford for the premier collectors event, the Zippo/Case International Swap Meet. On Thursdays of swap meet week, a special "Collectors Only" dinner and auction is held at W. R. Case & Sons's factory. Collectors are lined up to start their factory tour (above) before they head to the dinner tents behind the factory (below) to enjoy the incredible food and excitement of the auction.

Each swap meet features an auction, where rare items, prototypes, and other one-of-a-kind Case knives and Zippo lighters are offered. For the 2004 auction, original wildlife paintings by Case artist Andy Norcross were up for bid. He had created these designs for use in a series of commemorative knives sold by Case that year. The paintings, each with matching prototype Case knife in the frame, are shown from left to right by Misty Kimble, Denise Novak, Michele McCann, and Katie Ludwig. Auctioneer Ross Porter (left) is in the background with his assistant.

Darrell Leach is a member of the W. R. Case & Sons Wall of Fame. He spent much of his life accumulating one of the finest collections of Case knives and memorabilia. Whether setting up a huge display of Case knives at a show or ordering a Case Collectors Club knife for one of his grandchildren, Leach worked tirelessly to spread the message, sharing with others his love of Case knives. In this photograph, Leach has his display set up at the swap meet and is giving Case salesperson Mandy Jennings a lesson on his favorite knife, the Case Cheetah, while Eddie Jessup listens in.

Case Wall of Fame member Mary Petro (left) shares a story with Bunny Comilla, Case human resource manager, and Tom Arrowsmith, Case president and CEO during a Case Collectors Club dinner held at the University of Pittsburgh's Bradford campus during the 2004 swap meet.

Case Collectors Club administrator Lisa Boser points out something of interest in the *Case Collector* magazine to Ann Parnell during the 2004 swap meet. Case Collectors Club members will often plan their vacation schedules to allow them the chance to attend Case events held throughout the year.

Case collectors are known for their generous spirit, and there may be no better example of this kindness than Donald Tronetti. In April 2000, Tronetti contacted W. R. Case & Sons. His health was failing, and he wanted to donate his Case Trapper collection to the Zippo/Case Museum, wanting others to see and enjoy the collection that had been such an important part of his life. Donald Tronetti passed away shortly before the 2000 swap meet. His beautiful Case Trapper collection is proudly on display in the museum.

Case legend John R. Osborne Jr. and his sister Judy Osborne Orkus are on hand for the Case Wall of Fame Induction Ceremony held during the 2002 swap meet. They are accepting the honor on behalf of their father, J. Russell Osborne, and step-grandfather John O'Kain.

Case marketing and public relations manager Shelley Swanson (above) hosted a very special presentation at the 2004 swap meet. The Case family was on hand to place the journal of their family patriarch Job Russell Case on display in the Zippo Case Visitors Center and Museum. Members of the Case family are pictured below. From left to right are (seated) Minnie Case (whose husband Russell Case was a descendent of Edwin Case), Mike Kerns (descendent of Jean Case), John R. Osborne Jr. (descendent of W. R. Case) and Sheila Burrell (wife of John Burrell); (standing) John Burrell (descendent of Jean Case), Donna Case (descendent of Edwin Case) and Dean Burrell (descendent of Jean Case).

There is no better way to spend a Sunday afternoon than whittling with a favorite Case knife. That was certainly true for Robert Creech (age 8) and his brother Adam Creech (age 6). They sent this picture, with an accompanying story about their knife collecting and whittling, to the Case Collectors Club. Both picture and story were featured on the junior page of the *Case Collector* magazine.

In June 2001, W. R. Case & Sons hosted the 20th anniversary celebration of the Case Collectors Club at the Museum of Appalachia in Norris, Tennessee. The beautiful country setting was perfect for this festive event, with Case collectors swapping knives, telling stories, and sharing in the fun.

Helping youngsters learn about knife collecting and, more importantly, how to properly use a knife is top priority for W. R. Case & Sons. Julie Ford and Denise Novak are teaching a class to Case junior collectors at the 20th anniversary celebration in Norris, Tennessee. After completing their class, the kids all received their own Case Collectable knife to take home. As if learning about Case knives were not enough reward!

It looks like Tony Foster had the crowd going during the Expert Panel Forum held during the 20th anniversary event in Norris. Participants from left to right are Kevin Pipes (president of Smoky Mountain Knife Works), Jim Sargent (noted expert and author of *American Premium Guide to KNIVES & RAZORS*), Tony Foster (expert collector and publisher of a collector's price guide), and John R. Osborne Jr. (Case legend and the last Case family member to work for the company). Eddie Jessup (Case vice president of sales and marketing) is standing in front. Case will often hold these forums, giving new collectors a chance to learn from the real experts in the field.

E. L. "Shine" Jessup is pictured here with his son, Case vice president Eddie Jessup, at a Case legends tour stop. Shine started his career with Case in 1964, becoming the sales representative in the Tennessee and Kentucky territory. Building a relationship of trust with his dealers, Shine quickly became the top salesman for W. R. Case & Sons. A true friend to Case collectors, he developed the first special Case commemorative project, celebrating the Kentucky bicentennial. Even in retirement, Shine still helps train the newest Case salesman. He is indeed a Case legend and was named to the Case Wall of Fame in 2001.

Case authorized dealers around the country host special collectors events or "tour stops," often including a Case personality and an exclusive, limited-production knife. In addition to the Case president's tour, there are stops for Case legends, the Case historian, Case artisans, and a collectors' appreciation tour. Collectors at the swap meet were extremely lucky to have their certificates signed by three Case legends. Joining John R. Osborne Jr. (left) are Case Wall of Fame members Mary Petro and Bob Farquharson.

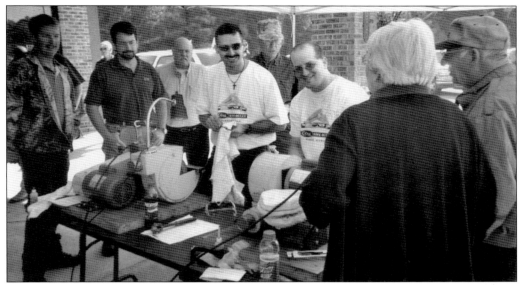

Whether it is a legend event, president's event, historian event, or collectors' appreciation stop, the real show is put on by Case associates. Using portable equipment shipped in from the factory, they hone and clean knives, making them shine like new. Chris Cole and Dave McKinney mesmerize the crowd at this historians' tour event at Parrish Ace Hardware in Alabama.

Years ago, when the hobby of knife collecting was just getting started, Bob Farquharson turned to Mary Petro to help him identify the time frame when different Case tang stamps were used. Petro has always been helpful; with her incredible 70-year tenure, she lived through so much of W. R. Case & Sons history. In this photograph from National Zippo Day, Case historian Shirley Boser shares a special moment with Mary Petro. They had worked together for many years before Petro retired in 1994.

In 2005, the Case Collectors Club returned to the Museum of Appalachia in Norris, Tennessee, for another Case celebration. Case director of marketing John Sullivan (left) is checking the students' progress (and making sure no Band-Aids are needed) at the clinic given by world-famous woodcarver Tom Wolfe. Wolfe has always carved using Case knives, and his classes are a favorite with Case collectors.

This is the "man behind the camera," Case IT manager Jay Bradish. In addition to keeping the computer systems up and running at Case, Bradish is a very talented photographer, often taking pictures at swap meets and other Case collectors events.

Case model maker Paul Lipps (left), custom knife maker Tony Bose (center), and Case president Tom Arrowsmith are observing the collectors' auction at the 2005 Norris, Tennessee, event. Case and Bose first started collaborating on knife designs in 1998. Bose's knives are among the most sought after by custom knife enthusiasts, with traditional designs famous for their dramatic blade grinds and incredible fit and finish. Bose works with the team at Case to build these collaborations. The resulting knives, like the Lock-back Whittler below, are the closest thing to a custom knife available from any factory.

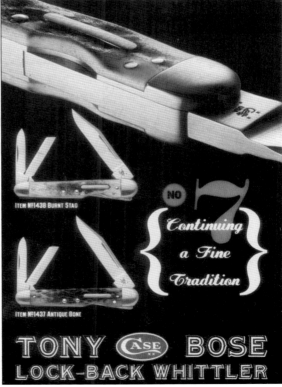

Greg Booth, Zippo president and Case chairman of the board rides in style on the Case Custom Chopper. The motorcycle, later given away in a sweepstakes, was built for W. R. Case & Sons in 2005 by Orange County Choppers, the firm run by Paul Teutel and his son Paul Jr., whose exploits were made famous on television.

The Case Custom Chopper toured the country in 2005, making some 75 stops. Case enthusiasts could see the latest Case knives, pick up a Case Custom Chopper T-shirt, and even have their picture taken on the motorcycle. Case vice president of sales and marketing Eddie Jessup, human resource manager Bunny Comilla, and controller Deb Eddy are working the chopper tour tent during the Norris Collectors Club event.

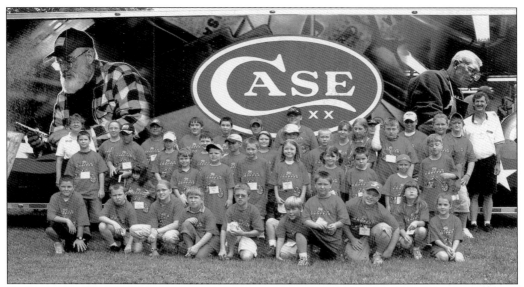

Becky and Rod Reid of Shepherd Hills Cutlery were kind enough to run the Junior Academy at the Norris Collectors Club event. The kids had a great time and posed for this picture after they finished their class. Note Case associates Ralph Banks and Larry Saar pictured on the side of the Case trailer in the background.

The proof is in the picture. Collecting Case knives is fun for kids of all ages. Junior collector Sheadon Allen is having Tom Arrowsmith autograph her knife box. She learned from the best, having traveled to other Case events with her grandparents James and Beulah Dawson.

While knives are an important part of the history of W. R. Case & Sons Cutlery Company, people are the real story. These are the associates of W. R. Case & Sons, still proudly crafting their knives by hand in a small factory in Bradford, Pennsylvania, still carrying on the traditions started by Russ Case more than a century ago.